# the photographer's guide to Acadia National Park

## Where to Find Perfect Shots and How to Take Them

Jerry and Marcy
Monkman

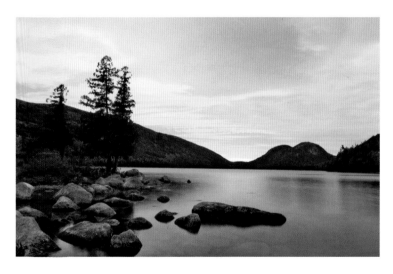

THE COUNTRYMAN PRESS
WOODSTOCK, VERMONT

The Photographer's Guide to Acadia National Park
ISBN: 978-0-88150-886-4

Maps by Paul Woodward, © The Countryman Press
Book design and composition by S. E. Livingston

Published by The Countryman Press,
P.O. Box 748, Woodstock, VT 05091

Distributed by W. W. Norton & Company, Inc.,
500 Fifth Avenue, New York, NY 10110

Printed in China

10  9  8  7  6  5  4  3  2  1

*Title Page: After sunset on Jordan Pond*
*Right: The Beehive as seen from the dunes at*
*Sand Beach*

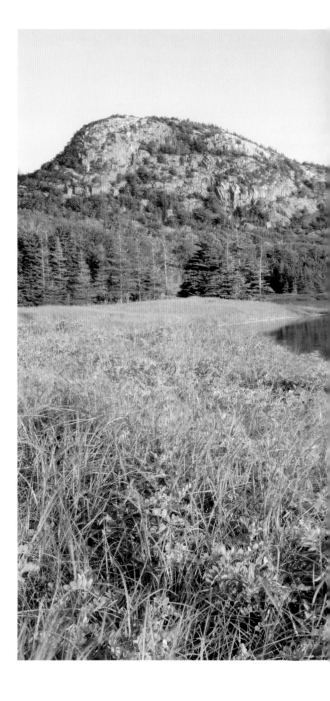

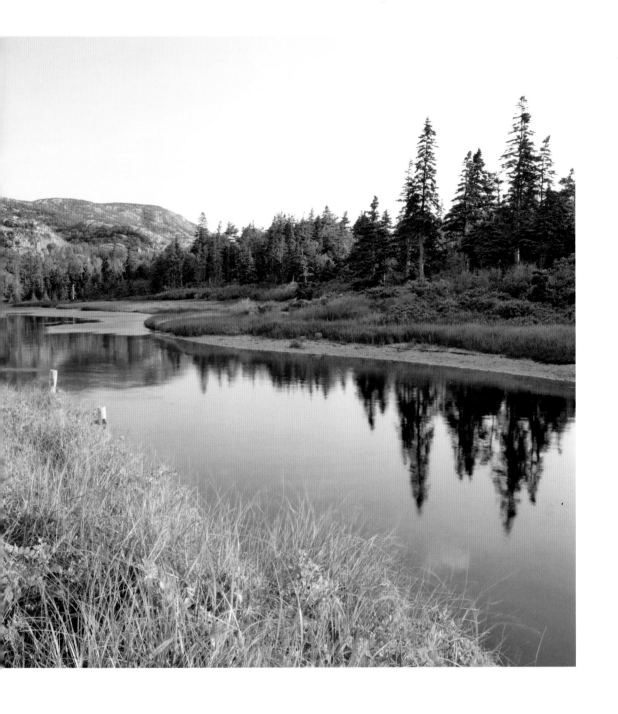

*For our favorite budding eco-photographers,
Acadia and Quinn*

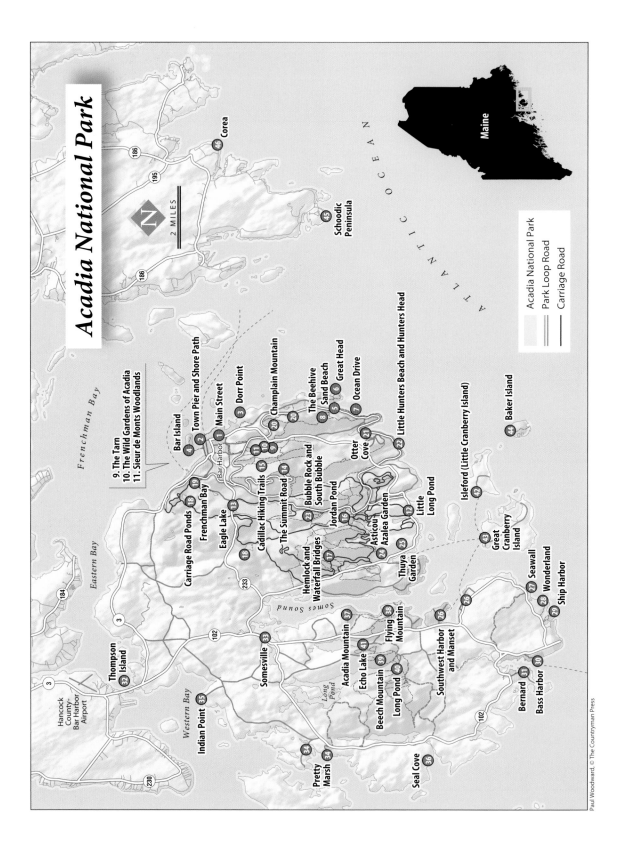

# Acadia National Park

Maine

Frenchman Bay

Eastern Bay

Western Bay

ATLANTIC OCEAN

N
2 MILES

9. The Tarn
10. The Wild Gardens of Acadia
11. Sieur de Monts Woodlands

Acadia National Park
Park Loop Road
Carriage Road

Hancock County–Bar Harbor Airport

Thompson Island 32

Indian Point 35

Somesville 33

Pretty Marsh 34

Seal Cove 36

Acadia Mountain 37

Echo Lake 41

Beech Mountain 39

Long Pond 40

Flying Mountain 38

Southwest Harbor and Manset 26

Bernard 31

Bass Harbor 30

Seawall 27

Wonderland 28

Ship Harbor 29

Great Cranberry Island 3

Isleford (Little Cranberry Island) 42

Baker Island 44

Carriage Road Ponds 18

Frenchman Bay 19

Eagle Lake 13

Cadillac Hiking Trails 15

The Summit Road 14

Bubble Rock and South Bubble

Hemlock and Waterfall Bridges 23

Jordan Pond 16

Asticou Azalea Garden 24

Thuya Garden 25

Little Long Pond 12

Otter Cove 21

Little Hunters Beach and Hunters Head 22

Ocean Drive 7

Great Head 6

Sand Beach 8

The Beehive 5

Champlain Mountain 20

Dorr Point 3

Main Street 1

Town Pier and Shore Path 2

Bar Island 4

Bar Harbor

Schoodic Peninsula 45

Corea 46

Somes Sound

Long Pond

Maine

Paul Woodward, © The Countryman Press

# Acadia East

Lubec

West Quoddy Head

Quoddy Narrows

Campobello Is.

Grand Manan

Wallace Cove

Baileys Mistake

Moose Cove

South Trescott

CANADA

U.S.

Maine

Cutler

Little Machias Bay

Machias Seal Island

Rocky Lake

Holmes Bay

Machias Bay

Dog Town

Gardner Lake

Jacksonville

Larabee

Bucks Harbor

Rocky Lake

Machias

Englishman Bay

Hadley Lake

Marks Lake

Shorey Cove

Chandler Bay

Monsapec

Gulf of Maine

Big Heath

Jonesport

Beals Island & Great Wass Island

Wohoa Bay

Western Bay

N

5 MILES

# Acadia National Park — West

Western Bay

Blue Hills

53 Castine

North Brooksville

Flat Landing

Cape Rosier

Eggenmoggin

Black Corner

Blue Hill Reversing Falls 54

Long Island

Sargentville

Mt. Desert Island

Brooklin

Blue Hill Bay

Deer Isle 55

Naskeag

Sunset

East Penobscot Bay

Jericho Bay

Stonington 56

Toothacker Bay

Minturn

Vinalhaven

Isle au Haut 57

N

5 MILES

Maine

# Contents

*Skiffs at a dock in Southwest Harbor*

# Introduction

Acadia National Park has been inspiring artists for more than 150 years. In the 19th century, before the area was designated a national park, Hudson River School artists such as Thomas Cole and Frederic Church painted here, bringing back to the cities of the Northeast canvases of iconic scenes from Eagle Lake, the Beehive, and the Porcupine Islands. Throngs of tourists followed, and the popularity of the area continues to this day. In the 20th century, the park's iconic landscapes were shot by America's best nature photographers, including Ansel Adams, David Muench, and William Neill. In the 21st century, Acadia is still a Mecca of sorts for photographers, with numerous photo tours visiting the park each year and plenty of tripods in use at popular spots such as the summit of Cadillac Mountain and Otter Cliffs.

And why wouldn't photographers want to make Acadia part of their plans? The park has most of what the New England landscape has to offer, packed into a relatively small space. Bald granite domes rise above lush forests dotted with scenic lakes and ponds. Acadia features some of the most dramatic coastline in the eastern United States, with cliffs rising more than 100 feet above the ocean interspersed with secluded coves that are ringed by pink granite ledges or filled with diverse collections of cobblestones. Bald eagles, peregrine falcons, and ospreys patrol the skies. Seals, porpoises, and a variety of seabirds ply the bays and narrows, while the calls of loons echo across inland waters. Throw in some foggy mornings and the working harbors that seem to be frozen in time; the photo opportunities are nearly endless.

Though we live in New Hampshire, the Acadia region has been like a second home to us for nearly 20 years. It is the first place we paddled sea kayaks and photographed harbor seals. We named our daughter Acadia in 2001, and the park is where both of our kids hiked their first mountain, caught their first fish, and built their first fairy houses. This place has become a part of us and we can't seem to visit it enough. The first book we ever proposed to a publisher was a photo guide to Acadia—in 1997. We were turned down then but have written six books since, so we were pretty excited when the Countryman Press asked us to share our love and knowledge of the park in this guide. Of course, since 1997 we have discovered and photographed dozens of new places in and around Acadia, which makes this much more comprehensive than the book we would have written originally—lucky you!

If you are planning your first visit to Acadia, this book should help you maximize your time there. We guarantee you will be inspired to make a lot of pictures, and you will most likely return home with a little bit of the Maine coast forever a part of your soul. If you are a return visitor, Acadia probably has captured a piece of your heart already, but we hope this book inspires you to seek out some new places with your camera and to see old favorites in new ways.

# Using This Guide

Our goal with this book is to provide the photographer visiting Acadia National Park with a reference that's like having a private photo tour leader in your camera bag. While you can find good photo subjects almost anywhere in Acadia, most photographers don't relish the idea of driving around for hours hoping to chance upon the ideal subject matter just as the light reaches perfection. Park personnel and local tour guides are experts in providing advice about the best places to visit, but not all of them understand the nuances of what makes a site an ideal photo location. With this guide, we have listed the places where you will encounter the best photo opportunities, and detailed when these places are best photographed. This logistical information gives you the freedom to focus on your photography and let your creative juices do their thing.

In the following section, "Tips for Photographing the Maine Coast," we discuss some of the unique aspects of photographing in and around Acadia, and provide tips that we hope will help you bring back images that portray your subject matter the way you see it and in a way that communicates your vision to others. Making nice pictures in Acadia is easy in some places, but making great photos that tell the story of Acadia's drama or its intimate details takes extra craftsmanship. Our location suggestions and photo tips should put you on the right path to making those great photos. Your hard work, creativity, and personal vision should take care of the rest.

You should be aware of the fact that not every place listed in this guide is actually part of Acadia National Park. Most of Acadia is located on Mount Desert Island, but about half the island is private property. The non-Acadia locations we list are generally accessible to the public, but please respect the locals and private property when out shooting, so future photographers can have the same rewarding experience as those who go before them. In addition to Mount Desert Island, we also describe the Schoodic Peninsula and Isle au Haut, two remote parts of the park, as well as interesting photo spots on the Blue Hill Peninsula and Down East Maine. While Mount Desert Island has plenty of scenery to keep a photographer busy during a long weekend or even a few weeks, those of you making longer (or repeat) visits to the park will undoubtedly get the urge to explore some of these other nearby locations.

Lastly, we have included a chapter of our favorites, places that should be at the top of your list if you have a limited amount of time in the park, though we know from experience that one or two trips to Acadia will only fuel your desire to return again and again.

*Crab shell and sand patterns at Sand Beach*

# Tips for Photographing the Maine Coast

For us, the most important thing we can do to make great photographs is to actually make the effort to get out and shoot. It sounds silly, but if you don't get out of the office or studio and start exploring with your camera it doesn't matter if you memorize this guide word for word, you will never make great photos in Acadia National Park. Read up before your trip—this guide, as well as field guides and historic accounts of Acadia—and make notes of a few must-have photos that you envision making. A few Acadia locations have that one obvious spot where everyone puts his or her tripod, but most require more exploration and creativity. Once you are there, take the time to get to know the places you want to shoot, studying the big picture and the details at your feet, as well as the way the light highlights those details and casts shadows across the landscape. If you go slow and make only one great photo, you will feel more successful than if you fill a memory card of mediocre images.

## Light in Acadia

Painters and photographers long ago discovered that the quality of light is as important as composition and technical skill in making great art. You can have the perfect subject and find the perfect perspective to describe it, yet still wind up with a mediocre photograph if you don't use the right light. We have two favorite kinds of light for photographing in New England in general and Acadia specifically: the hour or so before and after sunrise and sunset (a.k.a. "the golden hour"), and the diffuse light of fog or high overcast skies. The key is to know when to use which light for which subjects.

The 3,000 miles or so of the Maine coast

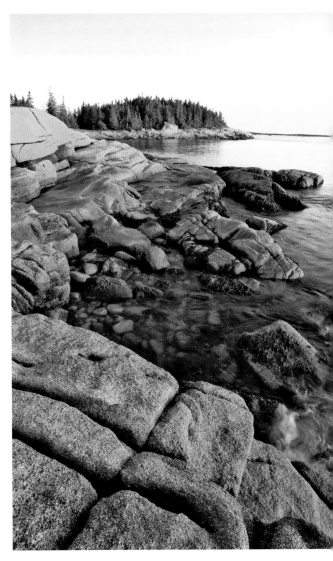

*"Golden hour" light on Great Wass Island*

twist and turn in every direction, and Acadia is no different. The great thing about this geographical feature is that you can find beaches, harbors, and coves that face sunrise, sunset, or any direction in between, which means there

are good opportunities to get that colorful light twice a day. Shooting the actual sunrise and sunset is a favorite activity of photographers, of course, but we find some of our best images come from using the light at that time of day to complement an interesting subject as opposed to focusing on the sunset or sunrise itself. The golden hour light is ideal for images of big open landscapes on the coast and up high on Acadia's bald granite peaks. Arriving at a location 30 minutes before sunrise is not too early, as it is a perfect time to silhouette trees, rocks, and people against the deep blues and oranges of the pre-dawn sky. Of course, you can get the same sort of photos by staying long after sunset.

Once the sun peeks over the horizon, go ahead and take your sunrise photos, but pay just as much attention to how this colorful light is painting other parts of the landscape. Shooting in a direction away from the sun will show your subject in a beautiful, low-contrast, warm light with interesting shadows and lots of detail. The same subject in high, midday sun will appear a washed-out blue, with harsh contrast between shadows and highlights. If you visit a location during the middle of the day and just fall in love with the photo possibilities, plan to return later that evening or the following morning. It might mean getting up at 4 A.M. and walking in the dark, but a better quality of light will improve your photos considerably.

Fog is very common in Acadia, especially in the morning, as sea breezes blow warm air over the cold waters of the Gulf of Maine. While fog can easily put the damper on a planned sunrise shoot, its soft light is ideal for many subjects, from lobster boats in a fog-enshrouded harbor to the lush moss and lichens of a spruce forest which seems to drip with green. Fog, as well as high overcast, is ideal for shooting most forest scenes, including waterfalls, streams, woodland flowers, and fall foliage. With high overcast, do your best to minimize the amount of sky in your photo, as it will be much brighter than your subject and distract your viewer's attention away from what you find interesting. With foggy harbor scenes, including the sky makes sense because the fog is as much a part of the image as the boats, trees, and rocks (just make sure to expose your image enough to keep the fog from looking too gray and dreary).

Fog can also be a localized phenomenon in Acadia, so if a sunny day is forecast and you wake up to thick fog, you might be able to find some locations that are in the clear. This is especially true on Mount Desert Island summer mornings when the prevailing wind is from the southwest and the fog moves over the island from south to north. On some days like this, driving to a northern location on the island will get you out of the fog and into the sun. It's also possible that the taller peaks on the island will be above the fog, so if you can get up high, you will be rewarded with some very dramatic landscapes where the sun rises above a layer of clouds.

## Gear

Shooting in Acadia requires the usual gear you would use in any nature photography location. All of today's digital single-lens reflex cameras (SLRs) are fine choices for shooting travel and nature photography, and many all-in-one cameras are also great for taking this type of shot. (Our suggestion is to get a camera that shoots in RAW format and has a lens with a good range from wide-angle to telephoto, i.e. 28mm to 200mm.) If, like us, your specialty is landscape photography, you will want both wide-angle lenses for big scenes, and moderate telephoto lenses (up to 200mm or 300mm is sufficient) to isolate landscape details. We typically also carry a macro lens for close-up work, as well as a flash or small reflector to use as fill

light. Compared to parks like Yellowstone or Denali, Acadia is not known for animal-rich locations, but a longer lens can be useful if you are a wildlife photographer and plan to visit sites known for loons or eagles, or if you take one of the several wildlife cruises offered from the harbors on Mount Desert Island.

In addition to our cameras and lenses, we almost always use a sturdy tripod when shooting. This is especially important if you shoot in the low-light situations discussed above, as you will regularly need to shoot with shutter speeds of 1/15 of a second and slower. Even with image-stabilized lenses and cameras, shooting at these slower shutter speeds will usually result in blurry images without the use of a good tripod. Tripods with adjustable legs are important to have in Acadia, as you are regularly shooting on uneven ground and you will appreciate having the flexibility of tripod legs set at different heights and angles. We also suggest using a cable release, to minimize camera vibrations when shooting. These minor vibrations might not be noticeable at smaller image sizes, but if you ever blow your images up to 8-by-10-inch prints or larger, you will want to have the extra sharpness that a cable release provides.

We also regularly use two types of lens filters when shooting in Acadia. The first is a polarizer, traditionally used to darken blue skies. The beauty of a polarizer is that the effect is immediately visible through the viewfinder or on your LCD. If you shoot during the golden hour you'll rarely use a polarizer, but if you shoot when the sun is higher, this filter will sometimes make skies more pleasing. However, avoid using a polarizer for this purpose with a wide-angle lens, as the image will look unnatural, with only part of the sky displaying the polarized effect. More often, we use a polarizer when shooting forest, waterfall, or flower scenes on foggy and overcast days. In these sit-

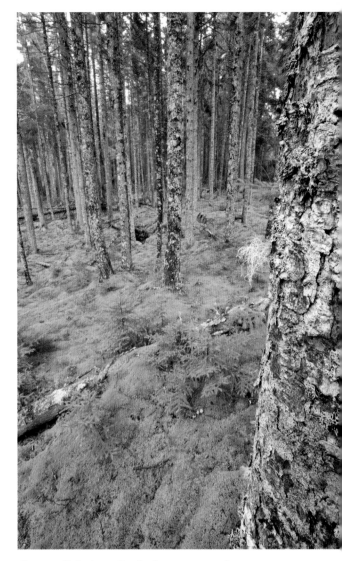

*Overcast light is perfect for forest scenes, when you can saturate colors with a polarizer.*

uations, a polarizer is essential to removing reflections on foliage and water, letting the true colors of your subject break through the glare that is usually present. If you have ever shot a fall foliage scene and thought the colors of your images were washed out, it could be that a polarizer would have helped saturate the colors to the level you saw with your eyes.

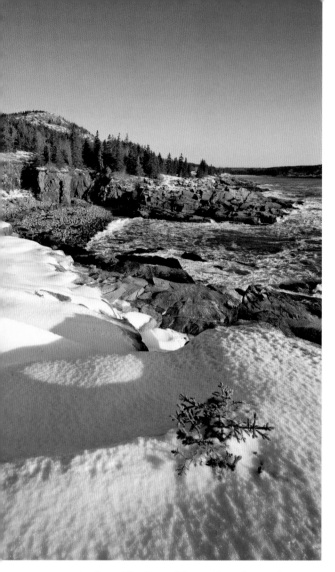

*Anchor wide shots with an object close to the camera.*

tion of your photograph (usually the sky) is much brighter than your foreground, which can be in shadow or low-contrast sunlight. By placing a graduated split-neutral density filter in front of your lens, with the horizon line on the filter matching the horizon line in the scene, you can balance your exposure by darkening the sky. These filters come in several strengths, but we usually find ourselves using a three-stop filter. You can also buy filter holders that attach to the front of your lens and hold the filter for you, allowing you to slide the filter up and down to match your horizon line.

## Getting the Shot

Having the right gear and the right light will set you up to shoot good images, but to truly make compelling pictures you need to add some compositional skills and creative vision to the mix. We've already mentioned the importance of using a tripod and filters. Here are some other basic tips that can make a big difference in your images:

### Get Close.

If you have to use words to describe the subject of your photo, then you should have moved closer. We love the effect of using a wide-angle lens up close and personal to a rock, flower, person, etc. These lenses let you focus from a short distance, exaggerating the size of your main subject and separating it from the background. Look at your LCD—if your subject takes up less than a quarter of the screen, move closer.

### Anchor Wide Shots.

Wide-angle lenses are great for photographing big landscapes, but without a strong foreground subject, the impact of your image can be just average. Find something interesting to place in the lower third of the scene—a flower, a pile of rocks, a cute kid—anything that gives

The other filter we carry is a graduated split-neutral density filter. This is a rectangular filter that has a neutral gray color on the top, and a clear bottom with a graduated blending of the two halves in the middle. This filter is essential for shooting big landscape scenes in Acadia, especially in early morning and around sunset. Often when using a wide-angle lens to shoot a location, you will find that the top por-

the viewer's eyes a place to land before exploring the beautiful landscape in the middle ground and background.

### Think About Depth of Field.

Depth of field is the amount of your photo, from front to back, that appears in focus. Small apertures (such as F16) and wide-angle lenses provide lots of depth of field, while big apertures (like F4) and telephoto lenses have a narrower depth of field. Big landscapes often look best with a large depth of field, where both your foreground and background are in focus. Using a narrow depth of field is a great way to isolate subjects, such as flowers and wildlife, from the background. Depth of field is one of the most important creative decisions you can make, so get used to thinking about it for every shot.

### Keep It Simple.

One of the greatest challenges of both nature and travel photography is translating a complex three-dimensional scene into a two-dimensional space that makes sense and has impact. When composing an image, crop out distracting elements that don't help tell your story and try to include only two or three compositional elements. Using a narrow depth of field or silhouettes is a great way to do this.

### Be Persistent.

Possibly the hardest thing for beginning photographers to do is learn patience and persistence, especially when shooting in a new or exotic place. There is a tendency to find a good subject, shoot off a couple of frames, and then move on, trying to photograph as many subjects

*Depth of field is an important creative decision. The image on the left has a large depth of field and was shot at F16. The image on the right is the same but with a narrow depth of field, shot at F4.*

as possible. When you encounter a scene or subject that excites you, slow down and take your time. Most often, the best composition doesn't materialize right away. Try different angles, perspectives, focal lengths, and F-stops. Really work your subject, and wait to see how the light and weather change. Chances are you will end up with more than one good photo and even a great one.

## Hazards to You and Your Gear

Acadia is a relatively safe place, but in some situations certain precautions are needed to protect yourself and/or your camera. The most common way people get hurt in Acadia is falling. Many of the trails in the park traverse steep rock faces which have good traction in dry weather, but in wet weather are downright treacherous. Wear good boots and, in bad weather, choose a hiking route that does not involve steep ascents and descents. On the coast, rock ledges can be dangerous even on nice days. The drop from these ledges is big enough to seriously injure or kill you if you fall, so be careful near the edges. Also, the tides are dramatic enough in Acadia (10 feet and higher) that many rocks exposed at low tide are much more slippery than they look. You can be rock hopping happily and then land on an algae-covered stone and suddenly find yourself on your backside or, worse, with a broken ankle or shattered camera. Also, big surf can spawn rogue waves that can knock you off your feet and carry you out to sea, so use common sense when shooting near the water.

Besides falls, the biggest threat to your gear in Acadia is moisture. Try to keep your camera from getting sprayed by salt water, as that will quickly destroy a camera's electronics. Your tripod can handle being placed in salt water, but rinse it off in fresh water as soon as you get back to your hotel or campground so the salt

does not corrode its few moving parts. While fog and even a light drizzle can make for great shooting light, subjecting your camera and lenses to constant moisture will eventually send you to the repair shop. In fog, rain, and snow, we like to shoot with some kind of cover on our gear. The Vortex Media SLR storm jacket (around $40) is a great permanent solution, while you can also opt for low-cost options that are less than $10, and are more like a plastic bag with a drawstring. Both options work, but which one you should get depends on how much you shoot in the rain. If your local camera shop doesn't carry rain covers, they are easy to find at online at retailers such as Hunt's Photo (www.huntsphotoandvideo .com). If you decide to kayak or canoe, you should stow your camera in a dry bag or purchase an underwater housing. We are not underwater photographers but we sometimes use the ewa-marine housings for our SLRs while kayaking—just in case.

The other hazards to consider are the same you'll find anywhere in a temperate environment like the Northeast—bugs, sun, and cold. Mosquitoes, black flies, and no-see-ums can all be annoying on any day from June through September, and of course they are most active at the best times to shoot—sunrise and sunset. Long sleeves, pants, and bug spray with DEET are your best defense. Ticks are not as common in Acadia as in other parts of New England, but you will still want to check yourself and your clothes at the end of the day if you've been in the woods or walking through tall grasses. The Maine summer sun can burn your skin quickly, so apply sunscreen several times a day if you are out in the sun. And a winter day in Acadia can be extremely cold and/or wet. Hypothermia is a real threat any time from October through April in Acadia. If you visit at this time of year, be sure to have proper winter clothing and gear, and backcountry experience if you

decide to explore beyond the parking areas. With fewer visitors and ranger patrols in winter, you will most likely need to rescue yourself if you get hurt, so bring friends, pay attention to the weather, and do not embark on a trip that is beyond your ability.

## Photographer Conduct

We find that most nature and travel photographers have a strong ethical sense, but it is worth thinking about proper conduct before heading out to shoot in Acadia. First and foremost, please consider the welfare of your subject to be more important than any photographs you are making. Comprising less than 50,000 acres, Acadia National Park sees more than 2 million visitors annually, so the flora and fauna in the park are greatly stressed each year, especially in the busy summer months. Consider your own impact before wandering off trail, moving closer to a wildlife subject, or venturing onto private property. Two photography organizations have excellent ethics statements that we feel all photographers should follow. You can find the ethics statement of the International League of Conservation Photographers on its Web site, www.ilcp.com/?cid=58. The North American Nature Photography Association has its Environmental Statement at http://nanpa.org/docs/EnvironmentalStatement.pdf.

We also believe that visitors to Acadia National Park should follow Leave No Trace standards while exploring the park. The principles of Leave No Trace can be found at www.lnt.org/programs/principles.php. Not only do these principles insure the health of the park, they can keep you from getting hurt, lost, or worse. Beyond these standards, visitors to Acadia should refrain from collecting anything from the park, even the rocks. With the exception of picking fruit, nuts, and berries for personal consumption, taking anything away—

*Simplify your images by eliminating distracting elements through composition or a narrow depth of field.*

cultural artifacts, wildflowers, animal parts, and rocks—is illegal. Even moving rocks to build cairns is against park policy, as it causes soil erosion and hikers can lose their way in the process. Please use common sense, leave the park as you found it, and pass up those photo ops that would require you to degrade the park's natural beauty or its enjoyment for others.

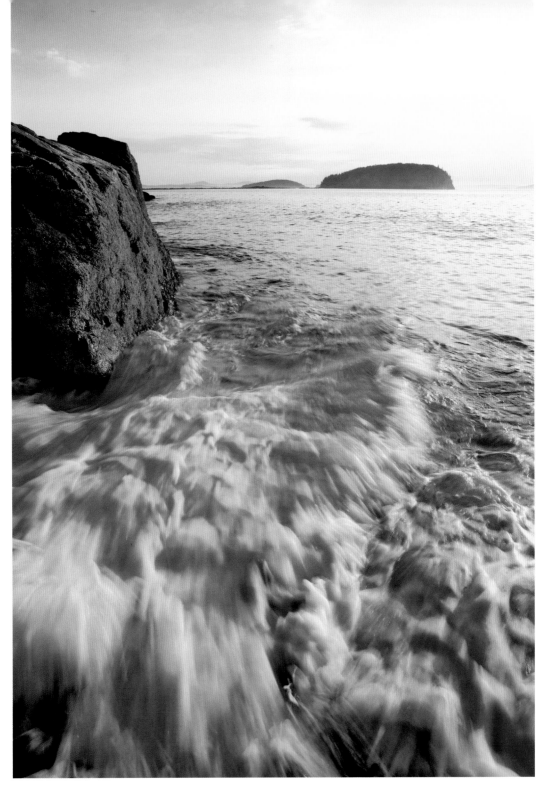

*Surf at Dorr Point*

# Eastern Mount Desert Island

## I. Bar Harbor and Environs

**General Description:** Bar Harbor is Acadia's tourist town. Its gift shops and restaurants make it busy and bustling in summer, but it is also surprisingly rich in photo opportunities, with a working harbor and easy shoreline access.

**Directions:** It is 11 miles to Bar Harbor on ME 3 from the bridge connecting Mount Desert Island to the mainland (it is 2.5 miles south of the park entrance).

## Main Street (1)

Downtown Bar Harbor is about 15 square blocks of homes, hotels, B&Bs, and storefronts bordered by Eden, Mount Desert, West, and Main streets. While the entire town is a joy to walk, the best photo ops are on Main Street, which starts at the harbor and runs south for several blocks before it becomes ME 3. If you like photographing colorful storefronts while enjoying a coneful of moose tracks ice cream, this is the place for you. Late afternoon and evening provide the opportunity to shoot the bustling tourist traffic, but we like shooting Main Street early in the morning, after shooting sunrise nearby. The tourists are still in their hotels enjoying a continental breakfast, leaving the streets empty and easier to shoot. Facing north from the intersection of Cottage Street you can get shots of the street sloping down to the water. Turn around and you can include Cadillac Mountain in your compositions. At the north end of Main Street there is a small park on a hill overlooking the town pier, Frenchman Bay, and the Porcupine Islands.

**Where:** Bar Harbor is on the eastern shoreline of Mount Desert Island.

**Noted for:** Restaurants and gift shops, the lobster boats in the harbor, and shoreline access with views of Frenchman Bay and the Porcupine Islands.

**Best Time:** Mid June through Columbus Day.

**Exertion:** Easy walking.

**Peak Times:** Spring: late May and early June. Summer: August. Fall: late September through early October. Winter: February.

**Facilities:** At the town pier and next to the fire station downtown.

**Parking:** Street parking and at municipal lots at the town pier and behind the fire station.

**Sleeps and Eats:** More than you can count in and outside of town.

**Sites Included:** Main Street, Town Pier and the Shore Path, Dorr Point, Bar Island.

## Town Pier and Shore Path (2)

The town pier at the ends of Main and West streets is simply a big parking lot with a few docks attached, but it provides numerous opportunities for making both sunrise and sunset photos of the harbor, lobster boats, kayakers, a four-masted schooner, and the occasional yacht or two. In addition to the diversity of boats, there are beautiful spruce-covered islands beyond the harbor in the scene. Bar Island and the four Porcupine Islands in Frenchman Bay are all protected as part of Acadia National Park and form the backdrop for one of the most recognizable small harbors on the Eastern seaboard.

After exploring the pier area, you can venture onto Shore Path, a crushed stone walkway

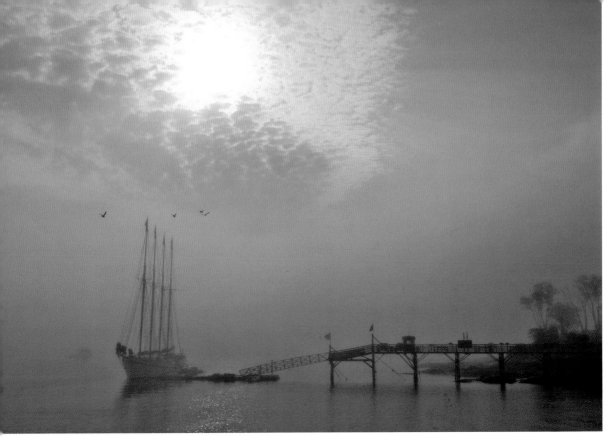

*Bar Harbor as the sun burns off morning fog.*

that starts at the Bar Harbor Inn (to the east of the pier) and follows the shoreline for 1.5 miles behind some beautiful inns and private homes. The path is a great sunrise choice, as it has unobstructed views east to the islands, Frenchman Bay, and the distant Schoodic Peninsula. The rock ledges and one big glacial erratic provide foreground material as well as opportunities to shoot close-ups. The path ends at Hancock Street, where you can either head back to Main Street or turn around and follow the shoreline back to the pier.

**Directions:** As you enter Bar Harbor on ME 3 from the north, you will come to a T intersection with the village green on your left. Turn left onto Main Street and follow it to its end and the town pier.

# Dorr Point (3)

Dorr Point is a little-visited part of Acadia National Park that is only a mile or so from downtown Bar Harbor. This part of the park was once the estate of George Dorr, who is generally credited with being the father of Acadia National Park for his tireless efforts on its behalf (he eventually served as the park's first superintendent). A half-mile walk through the woods brings you past the old stone foundations of his estate before reaching the shoreline. This is another great sunrise location, as you can get up on rock ledges overlooking Frenchman Bay and nearby Bald Porcupine Island. In June, lupines bloom on the edge of the ledges, making for great foreground material. There is also a small half-moon cobble-

stone beach you can scramble down to for a different perspective.

**Directions:** From the intersection of Mount Desert and Main streets downtown, follow Main Street (ME 3) south for 1 mile and look for the Acadia National Park parking lot on the left. The hiking trail is unmarked and there are several side paths. Take either of the first two lefts to get to the shoreline.

# Bar Island (4)

If you visit the town pier and stare across the harbor, you will probably wish you could get out to the island and do some shooting. You can, but only at low tide! For a few hours a day, Bar Island is connected to Bar Harbor by a rocky sand bar about .3 miles long. The bar is underwater about half the time, so plan your trip for the few hours around low tide.

There are some unique perspectives of the harbor from the bar itself, but we find it more interesting to cross the bar and hike onto the island. Follow the dirt road for about 300 yards and then follow the Bar Island Trail to the left for a .2-mile walk to the top of the island and its views of the harbor, the town, and the peaks of Acadia in the distance. We feel the town and mountains look best in the morning light, so if the tides permit, plan your trip then. On the way up you will also pass a field that is full of lupines in late June, making it a great place to stop and get lost in flower close-ups.

**Directions:** The bar can be accessed at the end of Bridge Street, about a quarter-mile walk up West Street from the town pier.

**Pro Tip:** If you feel hopelessly fogged in while in Bar Harbor, look for two things: boat and island silhouettes in the harbor, and the details at your feet as you explore the Shore Path, Dorr Point, or Bar Island. When photographing harbor scenes, pay attention to your expo-

sure. Your camera will meter all of that fog and provide you with an exposure that renders the fog a dirty gray. Most likely, you will need to open up one or more stops (by using a slower shutter speed than what your camera meter recommends). Check your LCD and your histogram to see if you are getting the fog bright enough—you will want to expose the scene so that the bell curve on the histogram reaches close to the right side of the graph. The ledges and cobbles of the shoreline are rife with colors and shapes that make for great abstract compositions. Study the shoreline as you walk, looking for patterns and interesting flotsam. A polarizer can help bring out the color in these close-up scenes by removing the glare caused by the water and dew on your subject.

*Lupines bloom on the shoreline in Bar Harbor*

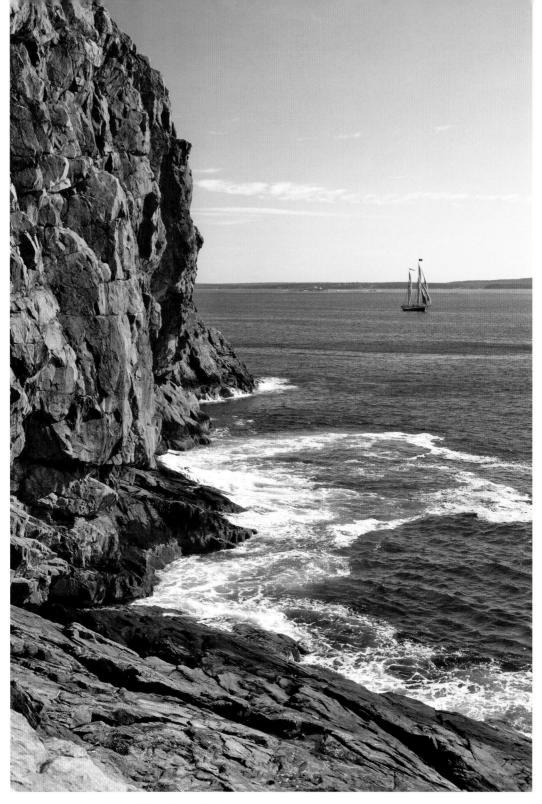

*A schooner sails past the cliffs of Great Head.*

# II. Sand Beach and Ocean Drive

**General Description:** The Ocean Drive section of the Park Loop, including Sand Beach, offers some of the most scenic coastline in all of Maine. Here you will find dramatic headlands, pink granite ledges being roughed up by the surf, cobblestone beaches, and of course, the sand and dunes of Sand Beach. This is one of the most popular sections of the park, but early morning photographers will find plenty of quiet moments and undisturbed landscapes to shoot.

**Directions:** From downtown Bar Harbor, head south on ME 3 for 2.1 miles and turn right at the Sieur de Monts Spring entrance to Park Loop Road. Following the signs for Sand Beach, drive 3.25 miles south on Park Loop Road to Ocean Drive and the Sand Beach parking area. Please note that there is an entrance fee to use the Ocean Drive section of Park Loop Road and the road is one-way from Sieur de Monts Spring past Ocean Drive to Jordan Pond.

> **Where:** Sand Beach and Ocean Drive are located on the southeastern end of Mount Desert Island, about 4 miles south of Bar Harbor.
> **Noted for:** Spectacular cliffs and ocean views.
> **Best Time:** Year-round.
> **Exertion:** Easy walking for some locations, short, steep hiking for the Beehive and Great Head.
> **Peak Times:** Spring: late May through June. Summer: July and August. Fall: late September through early October. Winter: January through March.
> **Facilities:** Memorial Day through Columbus Day only at Sand Beach and Thunder Hole.
> **Parking:** Several National Park parking areas along Park Loop Road and at Schooner Head.
> **Sleeps and Eats:** In Bar Harbor.
> **Sites Included:** Sand Beach, Great Head, Ocean Drive, the Beehive.

## Sand Beach (5)

Sand Beach is not your typical New England beach. Its 300 yards of beachfront are not that unusual, but nowhere else in the region will you find that stretch of sand hemmed in on both ends by tall pink granite cliffs. Add to the mix a small tidal creek that cuts through the beach, opening up views to a picturesque little hill known as the Beehive, and you are presented with a myriad of unique photo opportunities. The one downside to Sand Beach from a photographer's standpoint is that it faces south and the cliffs typically block that sweet golden hour of light at either end of the day. A good plan is to shoot sunrise from Great Head (see below) and then work your way toward Sand Beach as the sun rises, ending up there about an hour after sunup. At that time you will find decent light for shooting dune grasses, the Beehive, the surf, and sand patterns, as well as the big picture of the beach itself.

## Great Head (6)

Great Head is a great place for sunrise photography. Rising 145 feet above the Atlantic Ocean, the cliffs of Great Head offer several viewpoints facing east, south, and north, with the drama of crashing waves below. Good views can be had from the very top, where there are ruins of an old teahouse erected by the family of J. P. Morgan, who owned Great Head and Sand Beach before Morgan's heirs donated the

*Sunrise reflections, Ocean Drive*

property to Acadia National Park. To get shots of both the cliffs and the view, you will want to hike south and down a little way from the tea-house. Getting to Great Head takes a bit of effort, as you will need to hike .6 miles (pick up a map at the Visitor Center) from the east end of Sand Beach, up and over granite ledges populated by spruce and pitch pine. However, this little hike offers good views of both Sand Beach and the Beehive, giving you the chance to make photos with a different perspective of these park icons. You can also get to Great Head by hiking half a mile from the parking area off Schooner Head Road. This is a good option if you want to save about 15 minutes of walking before sunrise, which of course can be very early in eastern Maine in the summer.

**Directions:** You can reach Great Head from the Sand Beach parking area (described above) or from a parking area off Schooner Head Road. To reach this second parking area, drive south on ME 3 from Bar Harbor for 1.25 miles and bear left onto Schooner Head Road. Follow Schooner Head Road for 2.5 miles until you reach a stop sign. Go straight and park in the lot at the end of the road (turning left brings you to a nice view at Schooner Head, while turning right brings you to the Park Look Road just before Ocean Drive).

## Ocean Drive (7)

You can easily spend days just roaming and shooting along the Ocean Drive section of Park

Loop Road. A little less than 2 miles in length, the road parallels the coast from just above Sand Beach to an overlook at a cliff known as Otter Point. There are several places to park a car and explore the beautiful granite ledges that stretch for most of the 2 miles. Most of the ledges face east and a little south, making this a perfect location for sunrise photography. Since the road is one-way, we suggest taking a few hours to scout the length of Ocean Drive the day before your sunrise shoot, because if you pass up a spot you decide you want to shoot later, you can't backtrack in the car.

Besides the bevy of granite ledges, the hot spots on Ocean Drive to check out include Thunder Hole, a cleft in the granite that spouts huge plumes of water during the incoming tide when seas are high; the cobble beach in Monument Cove, across from the Gorham Mountain parking lot; the view from the top of Otter Cliffs; and the view from Otter Point. In addition to shooting the obvious grand landscapes here, you can also spend hours looking at the details of the coastline and playing with abstract compositions of rock and water. Wildlife photographers might also want to bring a big lens to photograph the eider ducks that often ply the waters below the ledges.

*The cobblestones in Monument Cove*

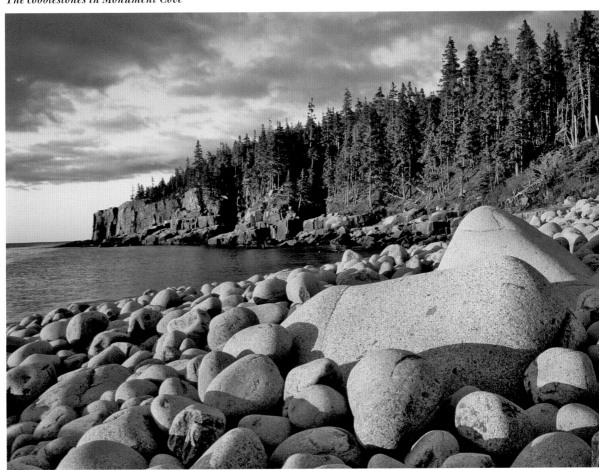

# The Beehive (8)

The Beehive is a curious-looking dome of granite that rises up behind Sand Beach to a height of 520 feet above sea level. Its steep rock face is almost devoid of trees except for a few clingy spruce and pitch pines. The views from the top of Sand Beach, Frenchman Bay, and the Atlantic are excellent and can be downright

*Sand Beach and the Beehive in fall.*

spectacular on a foggy morning if the summit rises above the socked-in coast below. There are also good views to the northwest of Cadillac Mountain. There are two ways to get up the Beehive. The first is not for the faint of heart, and includes climbing up the cliff face on metal rungs via the Beehive Trail. The less-steep alternative is a 40-minute hike up the Bowl Trail, which passes a picturesque little tarn known as "The Bowl" on its way to the summit.

**Directions:** The Bowl Trail can be found across the Park Loop Road from the Sand Beach parking area. The Beehive Trail leaves the Bowl Trail .2 miles from the road.

**Pro Tip:** Early morning photography in this section of the park often requires the use of a graduated split-neutral density filter to balance the exposure between sky and foreground. Meter your sky and foreground separately and if there is a difference of four stops or more, break out the filter. While moving the filter up and down to match your horizon line, use the depth-of-field preview button on your camera if it has one. This is especially helpful in lining up the horizon line when shooting at small apertures with big depths of field, like F11 and F16. Forget your filter? With your camera on a tripod, shoot the same scene several times, varying the shutter speed by one or two stops in each direction. You can do this manually or by using the auto-bracketing feature of your camera. Then when you download your photos onto your PC or Mac, you can combine the images in Photoshop using layer masks. By using one shot exposed for the sky, and one exposed for the foreground, the resulting image will look like you used the filter. If you don't know how to do this, look at our Outdoor Photographer blog, which explains the layer-masking procedure in layman's terms: www.outdoor photographer.com/community/blogs/in-the-zone.html.

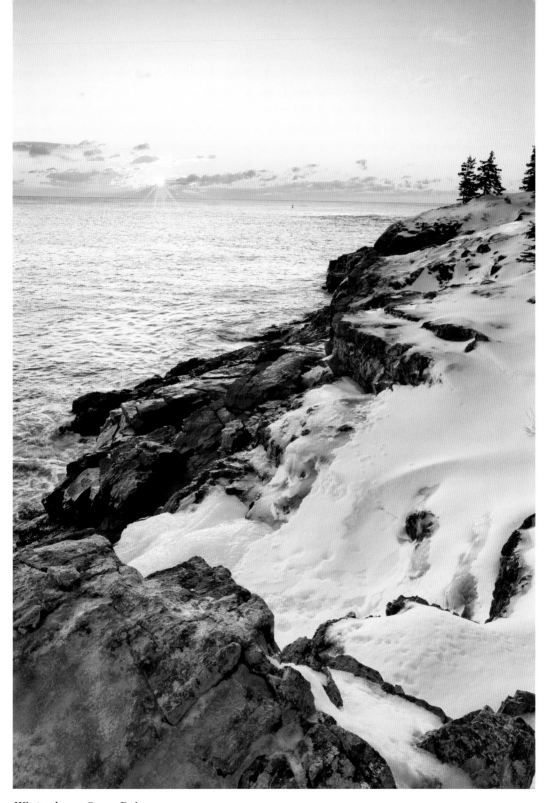

*Winter dawn, Ocean Drive*

*Fall colors on Kane Path near the Tarn*

# III. Eastern Mount Desert Island Roadside Ponds

**General Description:** The Tarn is a large glacial kettle pond situated below the steep, rocky slopes of Dorr Mountain. Nearby Sieur de Monts is home to the Abbe Museum (which specializes in the history of Maine's Native Americans), and the Wild Gardens of Acadia, a beautiful cultivated garden of ferns, shrubs, and wildflowers native to Mount Desert Island. Woodland trails meander through stunning paper birch forests and a marsh teeming with bird life. Little Long Pond and Eagle Lake both offer excellent views of the mountains across the water.

**Directions:** To Sieur de Monts: From downtown Bar Harbor, head south on ME 3 for 2.1 miles and turn right at the Sieur de Monts Spring entrance to Park Loop Road. Follow the signs for the parking area. For the Tarn, you can either walk from Sieur de Monts or park on ME 3, .1 miles south of the Park Loop Road entrance. Little Long Pond is on ME 3, another 6.7 miles south of Bar Harbor. Parking for Eagle Lake is on both sides of ME 233, 2.1 miles west of ME 3 in Bar Harbor.

## The Tarn (9)

The Tarn is a large pond carved by a glacier as it scoured the valley between the Dorr and Champlain mountains during the last ice age. From the north shore of the Tarn, you can easily make out the U shape cut through the mountains by the ice that may have been several thousand feet thick. This U shape makes a dramatic silhouette with the right early morning or late evening skies, though it does have to compete with the headlights of cars on ME 3. We usually find ourselves shooting one of two things here: the pickerelweed and water lilies

---

**Where:** The Tarn, Sieur de Monts, and Little Long Pond are on ME 3, southwest of Bar Harbor. Eagle Lake is on ME 233, west of Bar Harbor.

**Noted for:** Pond and mountain scenery, forest scenes, and the Wild Gardens of Acadia.

**Best Time:** Late spring through fall.

**Exertion:** Easy walking.

**Peak Times:** Spring: late May through June. Summer: July and August. Fall: late September through early October. Winter: January through March.

**Facilities:** Memorial Day through Columbus Day at the Sieur de Monts and Eagle Lake parking areas.

**Parking:** There are established lots at each location.

**Sleeps and Eats:** In Bar Harbor.

**Sites Included:** The Tarn, Wild Gardens of Acadia, Sieur de Monts woodland trails, Little Long Pond, and Eagle Lake.

---

*Ostrich ferns at the Wild Gardens of Acadia*

in the water, dwarfed by the steep rock face of Dorr Mountain, or the fall colors in the forest along the shoreline and on Kane Path, which skirts the western shore of the pond. Because the Tarn sits between Champlain Mountain to the east and Dorr Mountain to the west, do not expect a lot of light here at the very ends of the day. The best direct sunlight usually occurs in the morning, an hour or two after sunrise, depending on the time of year.

## The Wild Gardens of Acadia (10)

On less than an acre of park land, volunteers and Park Service personnel have created a beautiful collection of native habitats that represent 12 of Acadia's plant communities. It is a great place to photograph hard-to-find local flora such as yellow lady's slippers and Canada lilies. More than 300 varieties of plants grow here, and they are identified by signs, making this a great stop for any natural-history photographer building a library of stock photos of flora. What is even better is that the display has great aesthetic as well as scientific appeal—it is not just rows of labeled plants. Rather, it is a garden designed to mirror the natural environment. There is not one "peak" time to visit the garden. Fiddlehead ferns and early wildflowers start appearing in early May, but different wildflower species bloom throughout the spring and summer. While you're here, be sure to check out the Abbe Museum and the Sieur de Monts Nature Center, located next to the gardens.

## Sieur de Monts Woodlands (11)

The forests of Sieur de Monts are typical Maine woodlands—conifers and northern

*Yellow lady slippers at the Wild Gardens of Acadia*

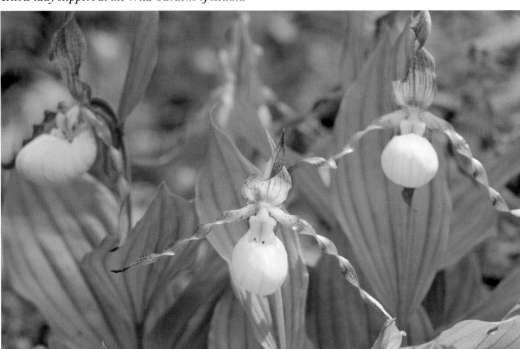

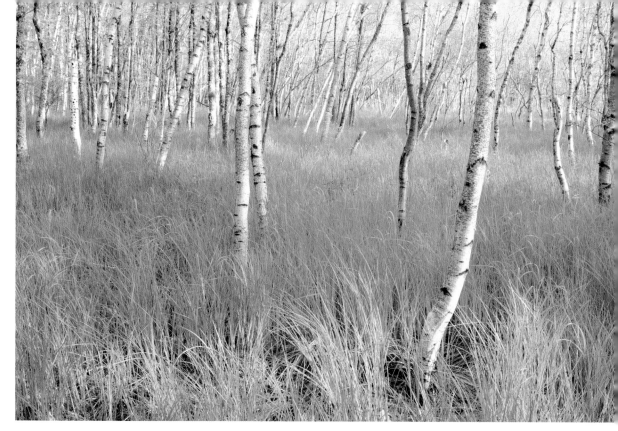

*Paper birch trees on the Jesup Path*

hardwoods—and they are accessible by several well-maintained trails in the area. By far, the most rewarding photo opportunities in these woods are the groves of paper birches that can be accessed by a short walk on the Jesup Path and the old Hemlock Road, both of which head north from the parking area. You will find great shots of birch trees lining the hiking trails, as well as pure stands of birch with an understory of tall grasses. This area floods from time to time, especially in the spring, so parts of Jesup Path may be closed, but you can still get good shots right at the beginning of the path near the parking area. Beyond the birches, Jesup Path and Hemlock Road traverse Great Meadow, a large freshwater wetland that is home to dozens of the 300-plus species of birds that can be found in the park.

It is an especially rich area for Neotropical migrants such as Nashville, magnolia, and black-throated green warblers, as well Eastern phoebes and several species of flycatchers.

## Little Long Pond (12)

A great morning location, Little Long Pond and the grounds surrounding it are owned by the Rockefeller family but open to the public (there is no fee). The landscape is full of graceful curves and mountain scenery. The pond is only about half a mile long, but it is a fun place to paddle or explore the shoreline via maintained grassy paths. The pond runs north-south, so it is not a sunrise/sunset location, but golden-hour light does reach the peaks in the distance and in the morning there is often the

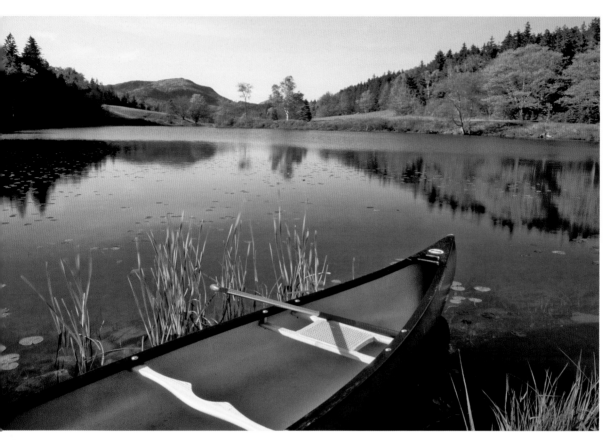

*A canoe at Little Long Pond*

usual Maine coast fog and mist to add drama and mood. Wildlife photographers will like the pond too, as there is an active beaver colony at the north end, as well as kingfishers, herons, ospreys, and lots of green frogs and bullfrogs. Directly across the road from the pond is a cobblestone beach in Bracy Cove, where you can also shoot the coast itself.

## Eagle Lake (13)

About 4 miles around its edge, Eagle Lake is one of the larger lakes on Mount Desert Island, and it makes a great place to canoe or kayak in the shadow of Cadillac Mountain. From a photographer's perspective, the best views are from the boat launch at the north end of the lake from the shoreline, along the half-mile walk on the carriage road heading east. The Cadillac and Pemetic mountains rise up above the far shore of the lake, their rounded summits making good subject matter for pre-sunrise silhouettes. It takes a little work to find foreground subjects, but there are enough rocks and reeds around that do the trick. If you're up for a long walk, a 6-mile carriage road circumnavigates the lake. About halfway up the western shoreline, you'll also find a short trail to the top of granite-clad Conners Nubble, which offers a great view of the lake and mountains from above. The peak fall foliage in this spot is spectacular. In winter, the lake is home to a few

dozen ice fishing shacks, or bob houses, which make interesting subjects by themselves but look especially nice with the mountains in the background during late afternoon.

**Pro Tip:** In the days of film, shooting green woods and flower close-ups worked great with saturated slide films such as Fuji Velvia, though a polarizer or warming filter was sometimes needed to punch up the scene and get the color right. With digital cameras, you will still need to use a polarizer much of the time to reduce glare on the foliage and saturate colors, but a warming filter isn't needed because you can use your camera's white-balance settings to control color casts. While the auto white-balance setting works fine for many nature subjects, we find that flower close-ups and forest scenes usually need some manual intervention because all the green in the landscape can throw off the camera's reading of color balance. If you are finding your images are lacking that lush green your eyes are seeing, adjust the white balance. First, you can try using the cloudy or shade white-balance setting. If the color still seems a little off, you can dial in your own custom white balance or take a picture of a white-balance card (we like the cards available from www.rawworkflow.com/whibal), which you can use in a program such as Lightroom or Adobe Camera Raw to set your white balance after the fact. Shooting in RAW format gives you greater flexibility when making this change.

*Eagle Lake at dawn*

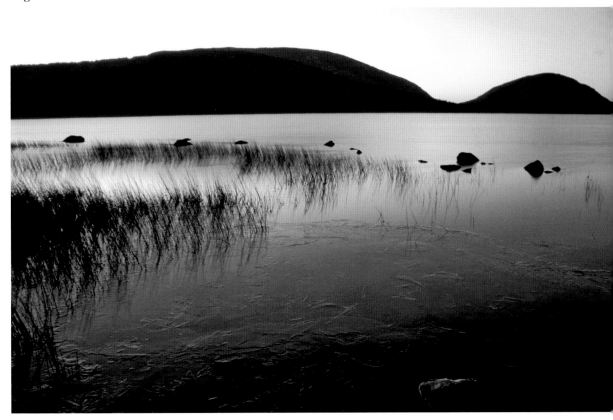

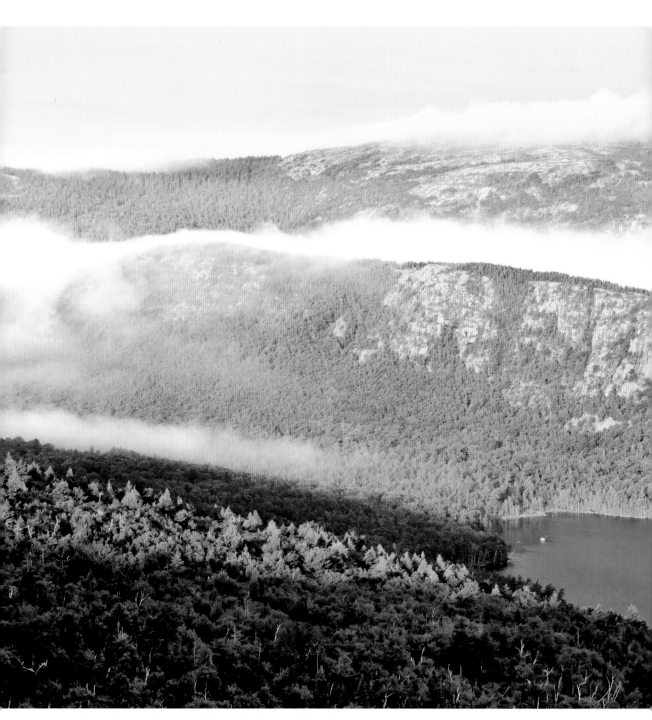

*Eagle Lake and Sargent Mountain from Cadillac Mountain*

# IV. Cadillac Mountain

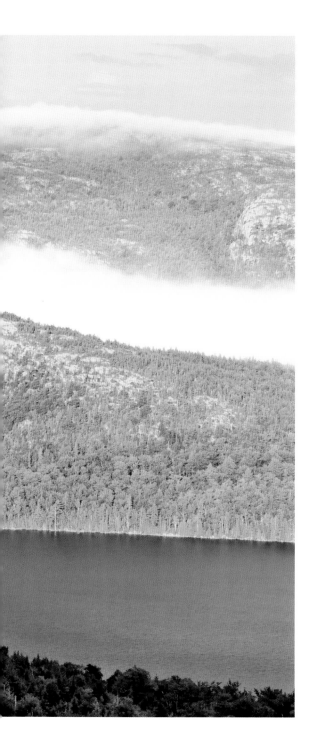

**Where:** The highest point on Mount Desert Island, accessible via an auto road from Bar Harbor.

**Noted for:** Sunrise and sunset views of the surrounding peaks, Frenchman Bay, and the Gulf of Maine.

**Exertion:** Easy walking, with the option for some strenuous hiking.

**Peak Times:** Spring: early June. Summer: July and August. Fall: late September through early October. Winter: January through early March, but the summit is only accessible via hiking trails.

**Facilities:** Memorial Day through Columbus Day at the summit gift shop.

**Parking:** Established lots.

**Sleeps and Eats:** In Bar Harbor.

**Sites Included:** The Summit Road, Cadillac hiking trails.

**General Description:** At 1,528 feet above sea level, Cadillac Mountain is the highest point in Acadia National Park and it is also the highest point on the entire Eastern seaboard of the U.S. Though relatively low in elevation, even by New England standards, Cadillac offers unobstructed views of green forests and blue sea in every direction. The summit is mostly treeless, with only lichen, sedges, and low-lying shrubs growing on the glacially scoured pink granite (known as Cadillac granite). Accessible by car and on foot via several hiking trails, the summit is one of the most popular spots in the park, so be prepared to share your experience with others. However, the views and photo opportunities are worth any lack of solitude.

**Directions:** The summit is accessible via an auto road that leaves Park Loop Road about

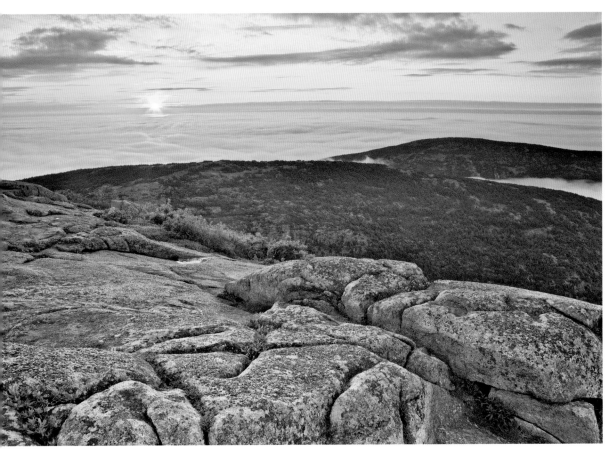

*Sunrise from Cadillac Mountain*

3.5 miles south of the Park Visitor Center, or about 1 mile south of the intersection of ME 233 and Park Loop Road in Bar Harbor. The summit road itself is 3.4 miles long.

## The Summit Road (14)

Known as the first place in the U.S. to be touched by the morning sun, Cadillac Mountain is a popular spot come sunrise, as sometimes hundreds of tourists drive their cars to the summit to participate in this Acadia tradition. This can be a little disconcerting to photographers used to being the only ones up and about that early, so mentally prepare yourself to share the experience. You'll definitely want to get there early to secure your photo spot, and you may even want to scout out the summit the night before so you can find the exact spot you want to shoot in the morning.

The classic Cadillac summit shot includes some Cadillac granite in the foreground, with the scene dropping off to the islands in Frenchman Bay and the rising sun. We also like to shoot tight silhouettes of the islands as the pre-sunrise light reflects on the water, and then wander over the eastern edge of the summit looking for small wildflowers and views of Otter Cove and the islands south of Mount Desert. Pay close attention to the weather forecast, because in the summer months it is not

*A waterfall on the Gorge Path on Cadillac Mountain*

uncommon for coastal and low-lying inland areas to be inundated with fog while the higher summits on the island are in the clear. This creates the opportunity for dramatic views of the sun rising over the fog-covered bay, with just a few high points in the landscape rising above the clouds.

At sunset, the summit proper is less interesting than several other overlooks on Summit Road. The biggest of these overlooks is the Blue Hill Overlook, just a few hundred yards west of the actual summit. This overlook offers the most direct view of sunset, with a view over Eagle Lake and toward Blue Hill and the Blue Hill Peninsula in the west. Like sunrise on the summit, sunset from the Blue Hill Overlook is a popular excursion and in busy season you'll have to contend with dozens of visitors scurrying about the granite. There are several other smaller, unmarked pull-outs along Summit Road that hold good photo potential, both at sunrise and sunset. One in particular, about halfway up, offers a great view down to Eagle Lake and the hills beyond.

## Cadillac Hiking Trails (15)

While the summit is an easy way to access some great photo opportunities, you may find the need to escape the crowds and explore some quieter or more intimate scenery. Two trails in particular offer some good photo opportunities on Cadillac. The South Ridge Trail is a 3.5-mile trail that connects the summit to Blackwoods Campground near Otter Cove. However, you don't have to hike the entire trail to get some good shots. You can drive to the summit and then hike the trail (which heads south from the gift shop) for about half a mile through a small grove of spruce trees to a wide-open, sweeping view of the Gulf of Maine and

*The Porcupine Islands as seen from Cadillac Mountain*

the islands south of Mount Desert. Another option is to hike up Cadillac via the Gorge Path, which climbs up 1,300 feet and 1.8 miles from Park Loop Road to the summit. This is a great trail for shooting on foggy mornings, as there are some interesting forest scenes and waterfalls along the way (wear your hiking boots).

**Directions to Gorge Path:** From the Park Visitor Center, drive south on Park Loop Road for 3 miles, then turn left toward Sand Beach. Gorge Path is on the right in about a mile.

**Pro Tip:** The summit of Cadillac Mountain offers great opportunities for making panoramic images. If you don't own a panorama camera, you can stitch multiple photos together in your computer using many software programs—Photoshop (www.adobe.com) and Panorama Maker (www.arcsoft.com) are both excellent

for this. In the old days (2006), doing a good job of stitching meant buying a special tripod head (for $300 and up) that rotated around the nodal point of the camera. These days, the software is so good that you can even hand-hold your shots and get reasonable results. Of course, we suggest shooting on a tripod that you have leveled with a bubble level. Also level your camera body. Shoot several images (in horizontal or vertical format), overlapping the scene from 30 percent to 50 percent between shots. This gives the software plenty of data points to make its stitching calculations. Combining several high-resolution photos can take lots of computer power, so if you have an older PC or Mac, be prepared to get a cup of coffee while your machine cranks through the data. This technique works well unless you have some fast-moving elements in the scene, such as waves, clouds, or people.

*A sugar maple and Jordan Stream next to a carriage road near Jordan Pond*

# V. The Carriage Roads

**General Description:** Fifty-seven miles of crushed gravel carriage roads were built in the park during the 1920s and 1930s under the direction (and with the funding) of John Rockefeller, Jr. Rockefeller built the carriage roads as a way for visitors to experience the backcountry of the park without the intrusion of automobiles. They have since become one of the most popular features of the park, their steady grades perfect for bike riding through beautiful hardwood and softwood forests, their handsome granite bridges ideally situated for lunch and water breaks. The 15 major bridges on the carriage roads are all suitable photographic subjects on their own, but many of them provide stunning views as well. In addition to the bridges, the carriage roads also provide access to several scenic ponds, including Jordan Pond, Aunt Betty's Pond, and Witch Hole Pond. While we have picked out a few highlights, the carriage roads were designed in such a way that a walk on almost any portion of the system is sure to yield some intriguing photo opportunities. Before heading out on the carriage road system, pick up a map or guidebook at the Park Visitor Center or Jordan Pond Gift Shop. You can also download a map of the carriage roads from the Acadia National Park Web site, www.nps.gov/acad/planyourvisit/upload/CRUMmap.pdf. Also, please note that in spring and after heavy rains, the carriage roads may be closed to bicycles to prevent erosion.

**Directions:** The carriage roads can be accessed from several parking areas, including those at Eagle Lake, Parkman Mountain, Bubble Pond, and Duck Brook Bridge. To park at the center of the system, follow Park Loop Road south

**Where:** On the eastern side of Mount Desert Island, accessible from several parking areas in the park.

**Noted for:** Beautiful hand-crafted bridges made of locally quarried granite, forest scenes, and pond and mountain views.

**Exertion:** Easy walking and bike riding, with the option for some strenuous biking.

**Peak Times:** Spring: early June. Summer: July and August. Fall: late September through early October. Winter: January through early March, on skis or snowshoes.

**Facilities:** Memorial Day through Columbus Day at Jordan Pond House and Parkman Mountain parking area only.

**Parking:** Established lots.

**Sleeps and Eats:** In Bar Harbor.

**Sites Included:** Jordan Pond, Carriage Road ponds, Hemlock and Waterfall bridges.

from the Visitor Center for 7.3 miles to Jordan Pond.

## Jordan Pond (16)

Jordan Pond is one of the classic Acadia landscapes, with the wide lawn of the Jordan Pond House sloping down to meet the water which reflects the perfectly rounded summits of a pair of granite domes known as the Bubbles. The pond is circumnavigated by the 3.3-mile Jordan Pond Trail, which is relatively easy except for a short traverse across a boulder field at the end opposite the Jordan Pond House. The classic shot is from the lawn or down on the pond along the first half-mile of trail as you walk it counterclockwise from the southern end. Running north-south between the cliffs of

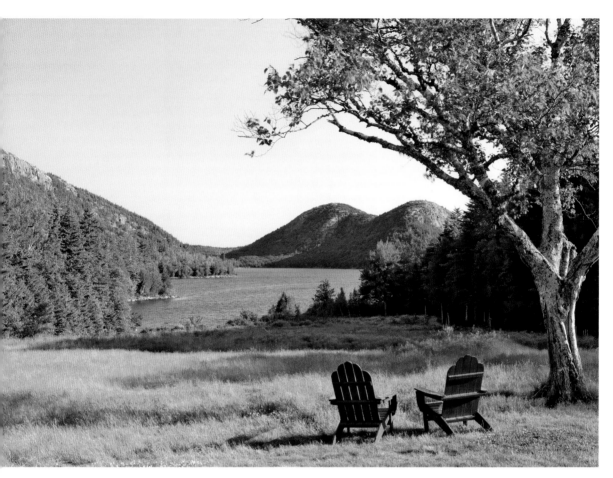

*The Bubbles and Jordan Pond*

Penobscot and Pemetic mountains, there are no direct sunrise/sunset views at the pond, but there you will find some dramatic side lighting shortly after sunrise and late in the afternoon.

The pond is also home to nesting loons and red-breasted mergansers, and there is interesting flora around it, including carnivorous sundew and wild orchids. Please use discretion when photographing these subjects, as Jordan Pond is a heavily traveled area and the flora and fauna already are under intense pressure. In addition to shooting the pond from the Jordan Pond Trail, you can photograph it from above by walking or biking the carriage road that tra-verses the slopes to its west. Of particular interest is the bridge over Deer Brook, near the northwest corner of the pond. It is a double-arch bridge framing a nice waterfall that tumbles over pink slabs of Cadillac granite.

## Hemlock and Waterfall Bridges (17)

All of the 15 bridges in the carriage road system are works of art worth photographing, but Hemlock and Waterfall bridges offer the most "bang for the buck" if you are short on time and have only one morning to explore the car-

riage road system. This pair of granite bridges, about a mile-long walk from the Parkman Mountain parking area, are only about 100 yards apart on the Around the Mountain loop of the carriage road system. This is the perfect place to visit on an overcast or foggy morning, as you will have the opportunity to do a variety of forest photography featuring a diversity of hardwoods and softwoods. Also, both bridges span small streams that, in medium to high water, offer a lot of photo opportunities. (In dry summer months, the streams are just a trickle.) Waterfall Bridge has platforms built into it just for viewing the waterfall on Hadlock Brook that tumbles down a 30-foot wall of granite before flowing under the bridge. By hiking the Hadlock Brook Trail down the slope from the bridge you can get a shot of the waterfall framed by a stone arch built into the bridge.

**Directions:** The Parkman Mountain parking area is on ME 3/198, 1.8 miles north of Northeast Harbor. You will need to walk or hike on the carriage roads for about a mile. Follow signs for Post 13, where you should turn left. Then turn right at Post 12, and follow the carriage road to Hemlock Bridge at .8 miles from the parking area. Waterfall Bridge is in another 100 yards or so.

*Stone work and waterfall on the Around the Mountain carriage road*

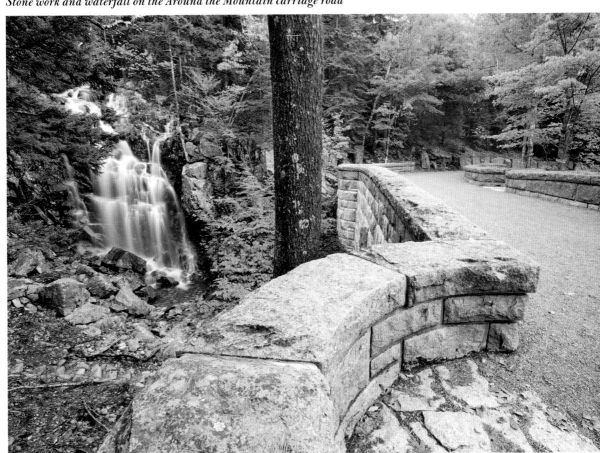

# Carriage Road Ponds (18)

In addition to Jordan Pond, the carriage road system also provides access to Upper Hadlock Pond, Bubble Pond, Witch Hole Pond, and Aunt Betty Pond. Witch Hole Pond (a short hike or ride from the Visitor Center or Duck Brook Bridge in Bar Harbor) is of interest to

*Winter ice and a small waterfall on a carriage road near Jordan Pond*

wildlife photographers as it has an active beaver colony. From a landscape perspective, Bubble Pond and Aunt Betty Pond are the most interesting of this group. Bubble Pond sports some great fall foliage and there are dramatic cliffs on the east side of the pond, where slabs of granite that peeled off Cadillac Mountain now lie in an enormous pile of stone that is known to attract perching turkey vultures. Aunt Betty Pond and nearby Gilmore Meadow offer good late-afternoon views of Sargent Mountain, the park's second-highest peak.

**Directions:** Parking for Bubble Pond is on Park Loop Road, about 2.5 miles north of Jordan Pond. For Aunt Betty Pond, you can park at the Eagle Lake parking area (see site 13) and then walk or bike 2.5 miles on the carriage road, turning right at Post 9. Witch Hole Pond is a .75-mile walk or bike ride from the Visitor Center or a 1-mile walk or ride from Duck Brook Bridge in Bar Harbor.

**Pro Tip:** If winter photography is your thing, then the carriage roads should be at the top of your list for a winter visit. The gentle grade of the roads (which are unplowed) makes them easier to snowshoe than the park's steep, rocky mountain trails, and they are ideal for cross-country skiing. The challenge is being there when the snow is skiable. Since Mount Desert Island is surrounded by ocean water, temperatures are more moderate than in inland Maine, and the freeze-thaw cycle of winter days often means the carriage roads are an icy mess. The key is to time your visit for January, when temperatures are at their coldest, or for a day or two after a fresh snowfall. You will also want a pack that comfortably carries your camera gear and a tripod (a light carbon fiber tripod is ideal) that gives you enough mobility to ski. Lowepro makes excellent packs for the adventuring photographer.

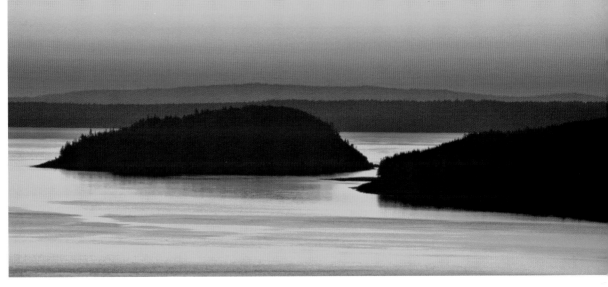

*The Porcupine Islands at dawn as seen from Park Loop Road*

# VI. The Park Loop Road

**General Description:** Acadia's Park Loop Road is easily one of the most scenic drives in New England, if not the nation, and it offers several great photo locations that can be visited time and time again. Its 20 miles conveniently climb to unobstructed ocean views before hugging the coast and passing hidden coves on the way to the deep forested interior of Mount Desert Island. We have described hot spots on the Park Loop Road previously—Sand Beach (5), Ocean Drive (7), Wild Gardens of Acadia (10), Sieur de Monts (11), Cadillac Summit Road (14), and Jordan Pond (16). This section highlights the best of the rest. We describe the points of interest in a clockwise direction, assuming you access Park Loop Road from the Visitor Center and turn left toward Sand Beach 2.5 miles south of the Visitor Center. There is an access fee to use the road, which is collected at a gate just before Sand Beach. The cost is $20 per vehicle (for a one-week visit) from June 23 through early October, and $10 from May 1

**Where:** On the eastern side of Mount Desert Island, with entrances in Bar Harbor and Seal Harbor.

**Noted for:** Twenty miles of scenic driving that explores Acadia's rocky shoreline and wooded interior.

**Exertion:** Easy walking, with some scrambling up and down short rocky trails or shoreline ledges. Strenuous hiking is optional.

**Peak Times:** Spring: early June. Summer: July and August. Fall: late September through early October. Winter: closed, except for the 2-mile Ocean Drive section.

**Facilities:** Memorial Day through Columbus Day at several parking and picnic areas along the route.

**Parking:** Established lots.

**Sleeps and Eats:** In Bar Harbor.

**Sites Included:** Frenchman Bay overlooks, Champlain Mountain, Otter Cove, Little Hunters Beach, Hunters Head, Bubble Rock.

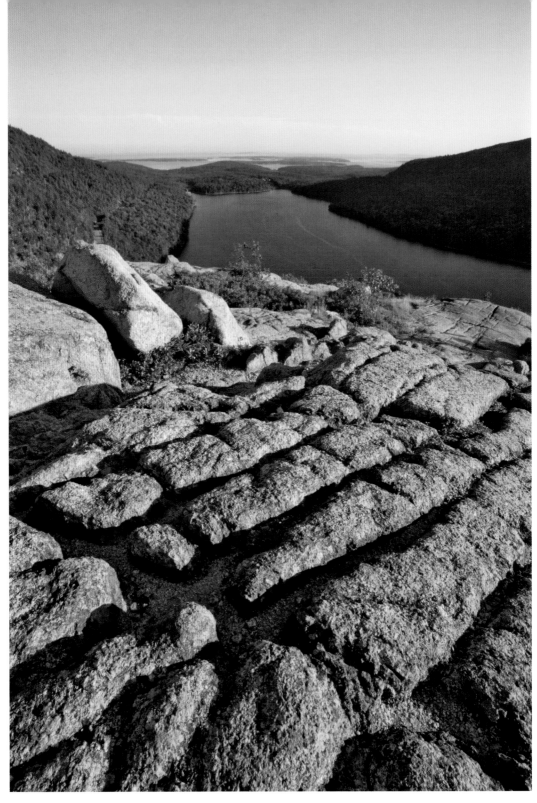

*Glacial scoured granite on the South Bubble*

through June 22 and early October through October 31. Except for the 2 miles at Ocean Drive, the road is closed during the winter months.

**Directions:** The Park Loop can be accessed at several points, but for this section we'll be describing it in relation to its start at the Park Visitor Center, located on ME 3, in Hulls Cove, about 2.5 miles north of Bar Harbor.

## Frenchman Bay (19)

Frenchman Bay is the body of water to the east of Mount Desert Island, and it is home to the Porcupine Islands. "The Porcupines" add great interest to the look of the bay, whether it is their forest-green foliage accenting the deep blues of the bay or their black silhouettes standing against the colorful reflections of a dawn sky. Good views of the bay and the islands can be had from several points on Mount Desert Island, including from downtown Bar Harbor and Cadillac Summit Road. Those from Park Loop Road offer a perspective in between those two vantage points, with several pull-outs in the first 7 miles or so, including perhaps the best view only half a mile from the Visitor Center. Get there before sunrise for those early-morning island silhouettes, or late in the afternoon for nice front lighting. You most likely will want a longer focal length lens (100mm or longer) to pick out compositions of islands, bay, and sailboats.

## Champlain Mountain (20)

At mile 6.4, just after the Bear Brook picnic area, there is a small beaver pond on the right that offers nice foreground possibilities for photos of Champlain Mountain and nearby Huguenot Head. Look for water lilies in summer and beavers at dawn and dusk. Champlain Mountain is best known for the cliffs on its east face, which rise about 900 feet in less than a

*Lily pads and cattails near Champlain Mountain*

third of a mile. To get a good look at the cliffs, continue on Park Loop Road to mile 7.7, where there is a parking area on the right for a trail called the Precipice, which climbs the east face of the mountain on a series of metal rungs. The Precipice is not for those afraid of heights or those in poor physical health (or for wet-weather hiking). The trail is also closed for much of the spring and summer because peregrine falcons nest on the cliffs, so wildlife photographers may wish to bring their long bird lens and a tele-extender. We've had some luck getting shots of the birds from the summit, which can also be accessed by easier "normal" grade hiking trails such as Champlain North Ridge Trail and Beachcroft Trail. The summit also has stunning views of Frenchman Bay and beyond.

## Otter Cove (21)

After passing the heroic landscapes of Ocean Drive, Park Loop Road passes through some woods before coming to a causeway that crosses Otter Cove at mile 11.8. While Otter Cove doesn't quite have the drama and variety of the ledges along Ocean Drive, there are some interesting landscape compositions to be had here, especially looking inland across the cove towards the park's granite domes. Early morning is our preferred time to shoot here.

## Little Hunters Beach and Hunters Head (22)

At mile 13.1, Park Loop Road passes a small pull-off with a view from Hunters Head, a headland that has a great view of the coast to the west. This is a fine spot for foggy coastal scenes or early morning light. At mile 13.5, there is a small pull-off on the right across the street from a set of wooden stairs that lead down a rocky bluff to one of those hidden gems in the park, Little Hunters Beach. Here a stream bisects a small half-moon cobblestone beach that faces south toward the Cranberry Islands. Though a small location, Little Hunters Beach offers both big landscape opportunities and close-up studies of shapes, shadows, and textures, as the cobblestones represent a collection of diverse rock types.

## Bubble Rock and South Bubble (23)

After passing Jordan Pond and traversing the western side of Pemetic Mountain above it, Park Loop Road reaches a parking area for

*Little Hunters Beach at sunrise*

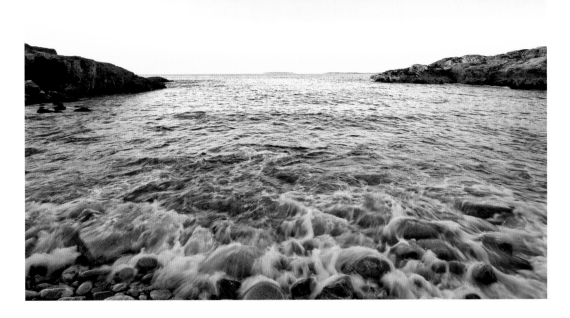

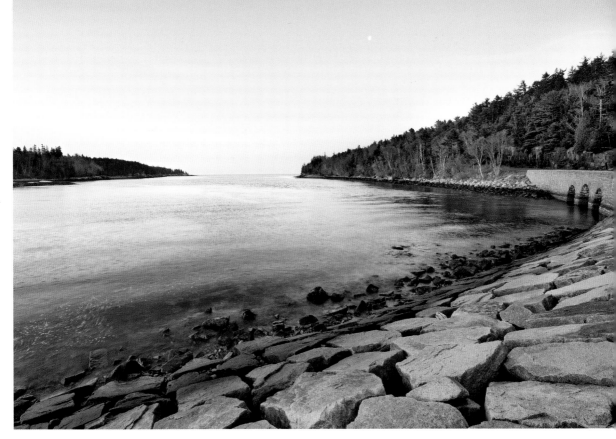

*Otter Cove before sunrise*

Bubble Rock at mile 18.6. Bubble Rock is a large boulder perched precariously near the summit of the South Bubble. Known as a glacial erratic, Bubble Rock was dropped onto the South Bubble by a glacier that carried the boulder for an estimated 40 miles (it is composed of a type of granite found in Lucerne, Maine). The rock is interesting to shoot from the parking area, but to really get a sense of its size, you need to climb the 400 feet up the South Bubble via a .7-mile trail accessible from a parking area .2 miles farther up the road. From the top of South Bubble, you also get excellent views of Jordan Pond and beyond. The granite of the ledges on South Bubble is marked by deep glacial striations, grooves carved into the rock by glacial activity during the last ice age.

**Pro Tip:** A trip to Acadia usually involves shooting lots and lots of images. If you travel with a laptop, you should make it a habit to download your images every night when you return to your hotel room or campground (you can't wait to see these photos anyway!). Hard drives are notoriously unreliable, so we always carry a matching pair of removable hard drives that plug into our laptop's USB port, and make duplicate copies of every image we download from our memory cards. We then reformat the cards in our camera, freeing the space for the next day of shooting. If you use a program such as Adobe Lightroom or Apple Aperture, you can easily set it up to make the duplicate copy of your images as they download, automating the process and setting your mind at ease.

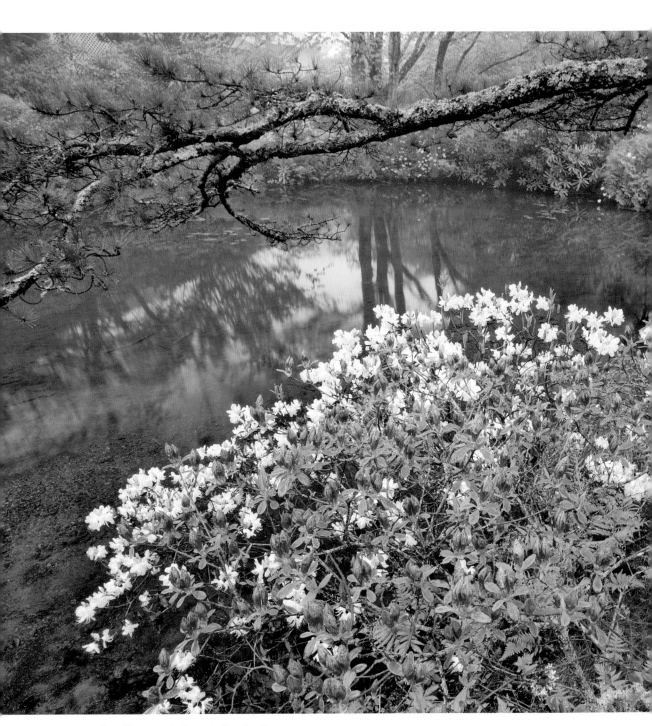

*Azaleas bloom at Asticou Azalea Garden*

# VII. Northeast Harbor Gardens

**Where:** Just outside of Northeast Harbor.
**Noted for:** Meticulously designed and maintained gardens.
**Exertion:** Easy walking.
**Peak Times:** Spring: early June. Summer: July and August. Fall: September. Winter: closed.
**Facilities:** At Thuya Garden.
**Parking:** Established lots.
**Sleeps and Eats:** In Northeast Harbor and Bar Harbor.
**Sites Included:** Asticou Azalea Garden, Thuya Garden.

**General Description:** Together, this pair of gardens makes up the Mount Desert Land and Garden Preserve in Northeast Harbor. Open to the public and less than a mile apart, the gardens offer two distinct experiences: The Zen-like, Japanese-inspired Asticou Azalea Garden combines small ponds and stone paths with well-manicured rhododendrons, azaleas, and other perennial shrubs and small trees, while Thuya Garden features a combination of English border beds and Maine woodlands. Both offer days of garden and close-up photography opportunities and they are photographer-friendly. There are no entrance fees to enjoy the gardens, but they do request a small donation.

## Asticou Azalea Garden (24)

Designed and built in 1956 by Charles Savage (owner of the nearby Asticou Inn) and financed by John Rockefeller, Jr., Asticou Azalea Garden excels at blending traditional Japanese design features with the Maine woods. Though worth a visit any time from mid-May through

*Thuya Garden*

October, the peak time for this garden is late May through June, when most varieties of rhododendrons and azaleas are in bloom. Just as interesting as the plants are the stone walkways and sculptures throughout the garden. A small pond and streams add water to the mix. We find this garden a joy to photograph on foggy days when the light is diffuse and the blooms are covered with drops of water. Be sure to bring your polarizer.

**Directions:** The Asticou Azalea Garden is on ME 198/ME 3, .1 miles north of the southern intersection of these two routes in Northeast Harbor.

## Thuya Garden (25)

Also designed and built by Charles Savage in 1956, Thuya Garden has a more open and airy feel than the intimate Asticou Azalea Garden. Its English-style flower beds enjoy full sun and show off a large variety of perennials and annu-

als that offer almost unlimited close-up photography opportunities. While Asticou peaks in June, Thuya's flower beds are in full bloom for most of the summer. The flowers also attract plenty of insect subjects, from honeybees to monarch butterflies. Overcast light makes for good flower portraits here, but since the flower beds are out in the open, you can make good use of early morning and late-afternoon sunlight as well. As much fun as the garden itself is the quarter-mile walk up the Asticou Terraces Trail, which leads from the parking lot on ME 3 to the gardens. While you can drive to the gardens proper, this walk is worth the extra effort. It starts at a boat dock on the harbor and provides several views of the harbor on the way up.

**Directions:** The parking area for the Asticou Terraces Trail is on ME 3, .3 miles south of ME 198. From this parking area, it is a quarter-mile, 250-foot climb on the trail to Thuya Garden. The garden is also accessible by driving south on ME 3 (from ME 198) for .6 miles, and turning left on Thuya Drive. Parking is at the end of Thuya Drive.

**Pro Tip:** While we like to use tripods for most of our shooting, going handheld with a macro in these gardens can be a real joy. By using a large aperture such as F4 or F5.6, you will be shooting with shutter speeds that easily allow you to hand hold your camera. This isn't ideal for big landscape shots, but for getting close to the flowers and making soft-edged close-ups, it works great and frees you to move around at will. Be sure to fill your frame with color and a couple of edges, one of which should be your main focus point. Also, autofocus is a big help in this style of shooting.

*The stone walkway leading to Thuya Garden*

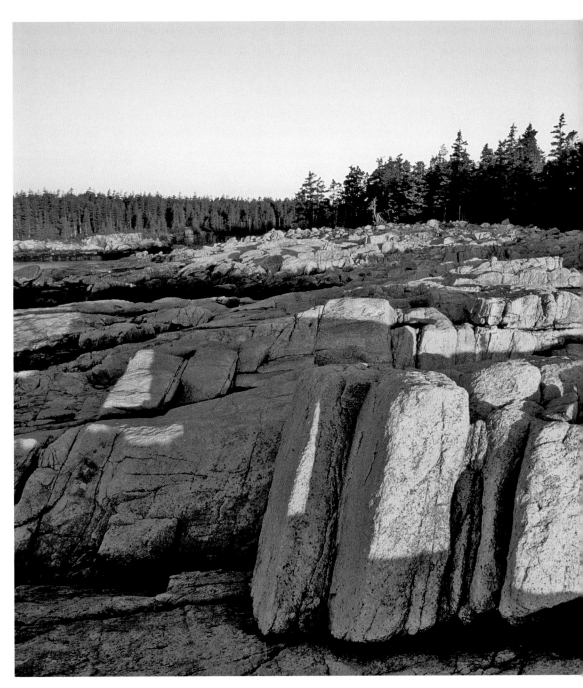

*Sunrise light on the ledges at Ship Harbor*

# Western Mount Desert Island

## VIII. Southwest Harbor and Beyond

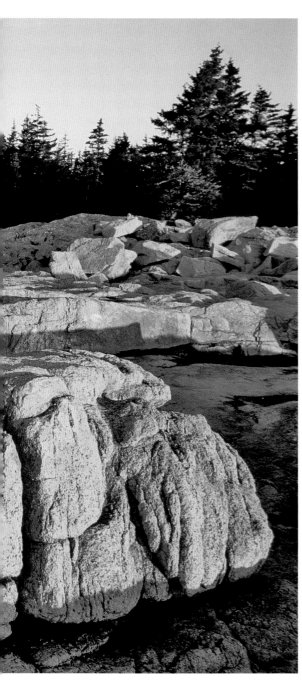

**Where:** On the western side of Mount Desert Island.

**Noted for:** Ocean views, tide pools, harbor scenes, Bass Harbor Head Lighthouse.

**Exertion:** Easy walking.

**Peak Times:** Spring: early June. Summer: July and August. Fall: early October. Winter: January through March.

**Facilities:** In Southwest Harbor, at the Seawall picnic area, at Bass Harbor Head Light parking area.

**Parking:** Established lots.

**Sleeps and Eats:** In Southwest Harbor, and a few in Bass Harbor. Camping at Seawall.

**Sites Included:** Southwest Harbor, Manset, Seawall, Wonderland, Ship Harbor, Bass Harbor, Bernard.

**General Description:** The eastern half of Mount Desert Island gets most of the attention, with the scenery of Bar Harbor and the nearby park attractions proving postcard-worthy at almost every turn. Of course, that makes the eastern side of the island very popular and crowded during busy times. The western half, in contrast, is known as "the quiet side" and receives fewer visitors, though it still has its busier parts. In general, the scenery on the western side of the island is not quite as dramatic as the eastern side, but there is still classic Maine coast beauty to be found here, and the harbors themselves are bustling with activity, crowded with fishing gear, and populated with locals who can make for some very interesting subjects.

This relatively small area on the western side of Mount Desert Island near Southwest

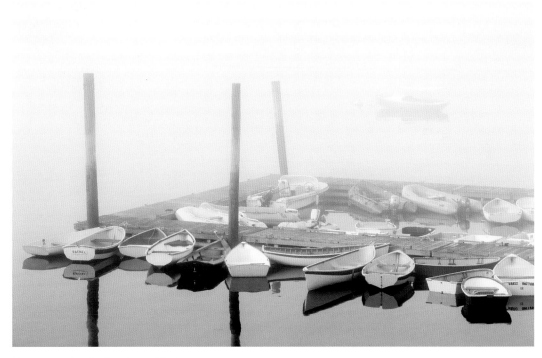
*Foggy morning in Southwest Harbor*

Harbor really packs in the photo ops. Fishing boats and lobstering gear, as well as a picturesque lighthouse, can be found in the harbors. In the park, the main shoreline access on the western side of Mount Desert Island is centered around the few miles of coast adjacent to the Seawall Campground. Compared to the dramatic headlands and ledges of the Ocean Drive section of the park, the areas known as Seawall, Wonderland, and Ship Harbor are relatively flat and understated, and the photos come with a little more effort and thought. However, all three spots provide ample raw materials for good shots in the form of ocean, rock, and trees.

**Directions:** Southwest Harbor is on the western side of Mount Desert Island on ME 102, about 6 miles south of ME 198 in Somesville.

# Southwest Harbor and Manset (26)

Lobster boats, sailboats, skiffs, traps, ropes, buoys—all the quintessential Maine coast paraphernalia can be found in Southwest Harbor and nearby Manset. Facing northeast, toward the mountains on eastern Mount Desert Island, Manset is a beautiful place to shoot at both sunrise and the hour before sunset. Southwest Harbor has a similar viewpoint, from ME 102, just south of the town center, though access is limited to the roadside pullout. To get to the good harbor scenes in Southwest, you need to visit the docks—the two public docks are on Clark Point Road. One is called the upper town dock, and the other is just before the end of the road and the U.S. Coast Guard Station. Both places offer

good opportunities to shoot harbor scenes as well as details of harbor life.

**Directions:** Clark Point Road, the main street heading east from ME 102 in the center of Southwest Harbor, leads to the town docks. To get to Manset, drive south on ME 102, and turn left on ME 102A. In about a mile, turn left on Mansell Road and drive to the end of the road and the harbor. Public parking is about .25 miles to the left on Shore Road.

# Seawall (27)

Seawall is a natural wall of small stones that protects inland marshes from the open ocean. Of the three locations listed in this section, it is the most accessible, though probably the least interesting. Except for a few tall spruce trees, the landscape is flat and the rocks are mostly white and gray. Still, the area gets good light at both ends of the day, which, combined with the trees and some good surf or fog, can make for very nice photos. Across the street is the Seawall Campground, and at the very back of the campground is the gated Hio Road, which you can walk if you want to explore the Big Heath, a wetland area full of scrubby spruce trees, skunk cabbage, carnivorous plants, and many small birds of diverse species. The best place to park is in the picnic area, which is on the left side of the road as you approach from Southwest Harbor.

**Directions:** Seawall is on ME 102A, 2.8 miles south of Southwest Harbor.

# Wonderland (28)

It takes about a mile of easy walking to get to the section of coast known as Wonderland, an area rich in tide pools. Like Seawall, it has good light both at sunrise and sunset, as the area curves around itself, providing views to both the east and west. Also like Seawall, the landscape here is flat, but from a photographer's perspective it looks very different. The rock ledges are made of brown bedrock, and its color warms up nicely with golden-hour sunlight. The smattering of tide pools combined with a shoreline of spruce trees offer a variety of compositional elements—just try to time your visit when the tide is not at its highest.

**Directions:** Wonderland is on ME 102A, 4.2 miles south of Southwest Harbor.

*Lobster buoy at Seawall*

## Ship Harbor (29)

The next stop after Wonderland on 102A is the Ship Harbor Trail, a 1.3-mile (partially wheelchair accessible) trail that skirts a small, muddy cove known as Ship Harbor before reaching rocky coastline and the good photos about .6 miles from the parking area. Here, the ledges are closer to the pink of Cadillac granite than the browns and grays of Wonderland and Seawall. Like the other locations, Ship Harbor has good tide pools to explore (look for starfish and sea urchins) and offers excellent sunset views, though sunrise light is limited to the very end of the trail. Photographers with big lenses and good luck can try shooting the seals and sea ducks that ply the ocean waters, the shorebirds that feed in the mud of Ship Harbor at low tide, and the great horned owls that nest in the nearby forest.

**Directions:** Wonderland is on ME 102A, 4.5 miles south of Southwest Harbor.

## Bass Harbor (30)

Bass Harbor is a small working harbor—you won't find many pleasure boats here. It is a good sunset spot, with the best access on Shore Road, near the Seafood Ketch Restaurant (excellent food and views!). The real attraction of

*Bass Harbor Head Light at sunset*

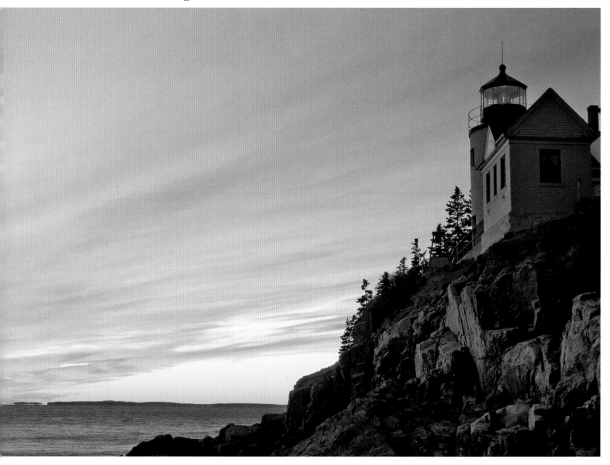

*Periwinkles and barnacles at Wonderland*

Bass Harbor for photographers, however, is the nearby Bass Harbor Head Light, a quaint little lighthouse perched on the classic rocky Acadia shoreline, complete with a perfectly hued red light. The challenge for photographers is that the sunset and sunrise are both obscured from this location for most of the year (in winter, when the sun is farther south, sunset is excellent). Usually, the best light hits the lighthouse in late afternoon, and sunset can look great if there are interesting clouds.

**Directions:** Bass Harbor is on ME 102A, 6 miles south of Southwest Harbor. To reach the lighthouse, turn left on Lighthouse Road, about 1 mile before reaching Bass Harbor. Parking for the lighthouse is on the right in .6 miles.

## Bernard (31)

Bernard is the small village directly across the harbor from Bass Harbor. Small is the key word here. There's not a lot to explore, but the views of the harbor from the town pier are excellent, and give more photo possibilities from the Bass Harbor side. In addition to offering good sunrise views, the town pier faces the western mountains of Acadia, which make a nice backdrop for harbor scenes shot at the end of the day.

**Directions:** From the intersection of ME 102A and ME 102 near Bass Harbor, follow ME 102 south for 1.1 miles, then turn left on Bernard Road. Follow this road to the end and turn right on Steamboat Wharf Road, which ends at the town pier.

**Pro Tip:** Tide pooling is a favorite activity of children, but photographers should add it to their checklist for any visit to the Maine coast. The coast at Seawall, Wonderland, and Ship Harbor offers good tide-pool photography, but don't expect to walk up and find colonies of starfish covering the rocks. Plan to visit within a few hours of low tide, when the tide pools are accessible (be careful on those wet, algae-covered rocks!). You will almost always find interesting compositions that include lichen, algae, periwinkles, barnacles, and blue mussels. On a good day you will also find starfish, sea urchins, and crabs. Don't move the animals and try to keep your hands out of the tide pools—all that sunscreen and bug spray can be detrimental to the health of the plants and animals. Look for abstract patterns and close-ups, concentrating on graphic compositions of color and texture. A polarizer will help remove the glare of light on the plants and animals above the water and the surface of the tide pools.

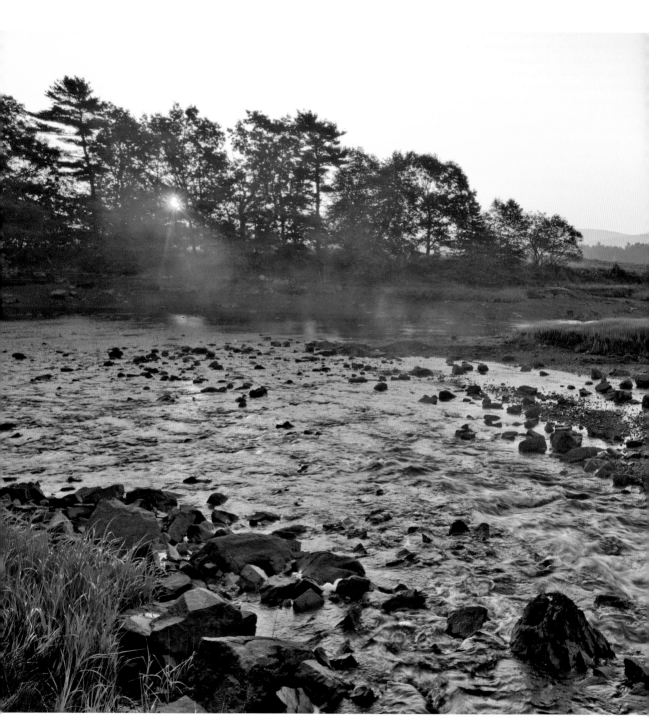

*Dawn in Somesville*

# IX. Somesville and Mount Desert

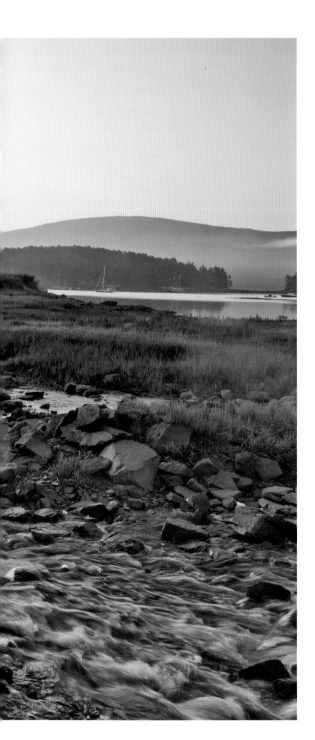

**Where:** On the western side of Mount Desert Island.
**Noted for:** Ocean views, wildlife, harbor scenes, Somesville Village.
**Exertion:** Easy walking to moderate hiking.
**Peak Times:** Spring: early June. Summer: July and August. Fall: late September and early October. Winter: January through March.
**Facilities:** Pretty Marsh Picnic Area, Thompson Island Visitor Center.
**Parking:** Established lots, except in Somesville, where there is roadside parking.
**Sleeps and Eats:** In Southwest Harbor.
**Sites Included:** Somesville, Blagden Preserve, Pretty Marsh Harbor, Thompson Island, Seal Cove.

**General Description:** We would call this area, most of which is in the town of Mount Desert, the quiet side of "the quiet side." It's on the western side of Mount Desert Island, but most people who make it this far head to those locations in Section VIII. Expect peace, quiet, and time to think—all good things for making better photos! The locations in this section will provide you with the opportunity to photograph a small Maine village, some rocky coastline, a small harbor with great sunset views, and possibly even some seals and other wildlife. Except for the convenience store at the Mobil station in Somesville, you won't find any commercial establishments, so if you're jonesing for ice cream or lobster you'll need to make the drive down to Southwest Harbor.

**Directions:** To reach these locations, you will need to follow the right fork onto ME 102 after crossing the bridge from Trenton to Mount

*Ice crowds the shoreline at Thompson Island.*

Desert Island (*after* Thompson Island, which lies between them).

# Thompson Island (32)

Thompson Island fills much of the space in Mount Desert Narrows between Mount Desert Island and the mainland along ME 3. On the island is the park's Thompson Island Visitor Center, the first official place in the park as people make the drive over. There are good views of the water, to the west behind the Visitor Center, and to the east across the street in the picnic area. There are some wetlands that often harbor great blue herons adjacent to the picnic area and a little farther down the road.

The area behind the Visitor Center is typical rocky Maine coast, and it is one of the few places in Acadia that we prefer to photograph in winter. After a stretch of really cold weather, ice starts to choke the narrows and small ice floes buckle and pile up on the rocks here. With crystal-clear winter skies, there is ample opportunity to make photos that seem almost Arctic. Just be sure not to walk out on the ice, as tidal currents constantly undermine it.

# Somesville (33)

Somesville, located on ME 102 just south of its intersection with ME 198, is a very small village without a whole lot of shooting opportu-

nities, but it is home to probably the most photographed spot on this side of the island. Right in the center of town the Somesville Historical Society maintains a beautiful white wooden bridge that forms an arch over a small mill pond. Check any postcard rack in Maine and you will probably find the picture that everyone makes of the bridge—straight on, usually in fall. Morning light is best for this shot, but we encourage you to try to make something new of this scene by shooting on the bridge or shooting details of the bridge and the nearby historic buildings and museum. Besides the bridge, you can also find some worthy compositions of Somes Sound from across the street, behind the public library.

## Pretty Marsh (34)

Pretty Marsh is on the northwest tip of Mount Desert Island. We have yet to find a pretty marsh there, but there are some pretty views worth photographing. When the eastern and southern parts of the island are encased in fog, you can often find clear skies in Pretty Marsh (don't hold us to that, though!). You can spot some nice field and water scenes just driving the area, but there are two prime locations to check out. The first is the Pretty Marsh picnic area, on Pretty Marsh Road, .4 miles south of Indian Point Road. Throughout the picnic area, you will find beautiful, undisturbed spruce-fir forest that is so mossy in spots that it practically glows green on a foggy or drizzly day. If it's shoreline you crave, drive to the end of the road and park. From there you can walk the short dirt fire road down to the shore and a cool picnic gazebo perched up on the rocks. There is a long stretch of cobble and gravel beach to explore, and this spot has unobstructed views of sunset.

If you want the same view of sunset but prefer to add a nautical theme to your photos,

head to Bartlett's Landing, about 2 miles to the north. Here you will find a small cove, complete with a pier and sailboats and lobster boats moored in the cove. Feel free to explore the pier while shooting, but remember to give the working fisherman space to do their job.

**Directions:** From Somesville, turn right onto Pretty Marsh Road just south of the village. On the way to Pretty Marsh, you'll pass a boat

*The famous bridge in Somesville*

launch to Long Pond on the left, then you'll see signs for Pretty Marsh when the road makes a long bend to the left. Stay left to get to the picnic area. For Bartlett's Landing, turn right onto Indian Point Road. In .2 miles, turn left onto Bartlett's Landing Road and follow it for 1.1 miles to the end, where there is a small parking area in front of the pier.

*The rocky shoreline at Indian Point*

# Indian Point (35)

Indian Point is home to The Nature Conservancy's 110-acre Blagden Preserve. Here you will find another fine forest of tall spruce and fir, as well as areas where trees have been blown down by the wind. To get to the shoreline you need to walk the 1-mile shore trail through the forest and a field, over a rocky and root-strewn path that will head mostly uphill on your return trip. It's worth the effort, though, as the coastline offers excellent views of Bartlett Narrows and there is a good chance to see harbor seals basking on offshore ledges (bring a very long lens). There is also the potential to see black guillemots and harbor porpoises in the water, as well as bald eagles and ospreys overhead. The field you'll pass through sports summer wildflowers, low-bush blueberries, and a diversity of butterflies and grassland bird species. The shoreline provides excellent sunset views. Unfortunately, the preserve closes at 6 P.M., which precludes photographing sunset during the spring and summer.

**Directions:** The Blagden Preserve is on Indian Point Road, 4 miles east of Pretty Marsh Road.

# Seal Cove (36)

Seal Cove is another one of those small Maine harbors that is rife with photo possibilities. While you won't find the fleet of lobster boats and all the gear that accompanies them that you would in Bernard or Southwest Harbor, there is usually a collection of small sailboats and a rocky shoreline nestled in a small cove surrounded by spruce forest. The cove faces west, so it receives great late-day light, though in early summer the sun sets a little too far north to be seen directly from the cove.

**Directions:** Seal Cove is on Cape Road, which is on the west side of ME 102, about .3 miles north of Seal Cove Road.

*Sunset lights the clouds above Bartlett's Landing in Pretty Marsh.*

**Pro Tip:** While the rule of thirds is something of a photography cliché, it can be a great rule to work with when you are having trouble making a composition work. With sunrise and sunset scenes like those you can photograph at many of the locations in this section, the main thing to remember about the rule of thirds is that you absolutely do not want to place your horizon line smack-dab in the middle of the frame. If you have a spectacular sky filled with glowing clouds, emphasize the sky by moving the horizon line down to the lower third of the image. If the sky is only average, find a really interesting foreground subject and feature it by making it large in the frame and moving your horizon line to the top third of the image.

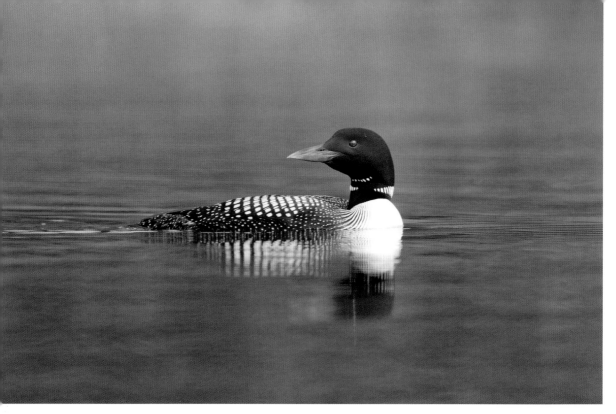

*Loons are common on Mount Desert Island, including at Long Pond and Echo Lake.*

# X. Western Ponds and Peaks

**General Description:** It takes more physical effort to shoot in this area than in any other section covered by this guide. The peaks and ponds on the western side of Mount Desert Island are beautiful and offer plenty of photo opportunities, but there are no "drive up and shoot" locations. If you want good photos from these places, you need to put some miles on your hiking boots or get out on the water in a canoe or kayak. The rewards are there—dramatic cliffs, stunning views, loons—but they come with effort and in some cases a little help from a partner (who can keep your canoe pointed in the right direction while you try to handle a big lens aimed at a loon).

**Where:** On the western side of Mount Desert Island.

**Noted for:** Forests, lake and mountain views, loons.

**Exertion:** Easy walking to strenuous hiking.

**Peak Times:** Spring: early June. Summer: July and August. Fall: late September and early October. Winter: January through March.

**Facilities:** Echo Lake Beach, in Southwest Harbor.

**Parking:** Established lots.

**Sleeps and Eats:** In Southwest Harbor.

**Sites Included:** Acadia Mountain, Flying Mountain, Beech Mountain, Long Pond, Echo Lake.

**Directions:** See individual location descriptions.

## Acadia Mountain (37)

Acadia Mountain and nearby St. Sauveur and Flying Mountains form the western wall of Somes Sound, the only fjord in the eastern United States. From the ledges on and near the summit of Acadia Mountain, there are excellent views of the sound, the islands at the mouth of the sound, and the mountains to the west. There is also a sparse forest of pitch pines on the summit dome that provides all sorts of photo opportunities. Early morning light works best here, and that means some hiking before dawn on the Acadia Mountain Trail, which climbs about 600 feet in just less than a mile. The pre-dawn hike is worth the effort, though, as you will get beautiful color in the sky and water and appreciate the silence that comes with being the first one up the mountain.

**Directions:** Parking for the Acadia Mountain Trail is on ME 102, 3 miles south of Somesville.

*Flying Mountain and Somes Sound from Acadia Mountain*

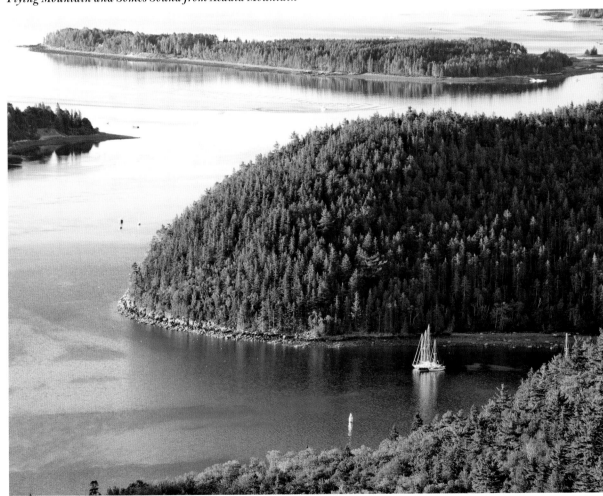

# Flying Mountain (38)

If the hike up Acadia Mountain seems too challenging for you to do before that first cup of coffee in the morning, you can opt for the easier hike up Flying Mountain to get your early morning shots of Somes Sound. The mountain stands at the south end of the sound, jutting out into the channel and giving excellent views of the Cranberry Islands as well as Norumbega and Cadillac mountains on the other side of the sound. The hike to the summit is about half a mile, with less than 300 feet of elevation gain. Hiking beyond the summit brings you to the shoreline in Valley Cove, where cliffs rise about 500 feet above the water.

**Directions:** Parking for the Flying Mountain Trail is on Fernald Point Road, .9 miles from ME 102 in Southwest harbor.

# Beech Mountain (39)

Nestled between Echo Lake and Long Pond, Beech Mountain provides views of both bodies of water and beyond from granite ledges and a fire tower on the summit. There is also a stunning, mature spruce forest on the Valley Trail at the south end of the mountain that makes a great subject on those foggy and drizzly days that are so common on the Maine Coast. A spider web of trails climbs to the summit, with Beech Mountain Loop Trail making the quickest ascent and Beech West Ridge Trail providing the best views of Long Pond—the sunset views of the pond from the ledges on this trail are excellent. Expect several hundred feet of elevation gain no matter which route you choose. The fire tower affords 360-degree views, of course, but it can be challenging to find good foreground subject matter from up top, so plan to bring a telephoto lens to pick out interesting subjects in the distance or to compress the landscape of receding ridge lines.

**Directions:** The Beech Mountain Loop Trail starts at the end of Beech Hill Road, 3 miles south of Pretty Marsh Road in Somesville. Beech West Ridge Trail and Valley Trail start at the parking area at the south end of Long Pond, which is at the end of Long Pond Road in Southwest Harbor.

# Long Pond (40) and Echo Lake (41)

These two long and narrow bodies of water share similar topography. Their northern ends are surrounded by relatively flat, forested terrain with a shoreline dotted by vacation homes and private boat docks. The southern ends are part of the national park and feature wild, undeveloped shorelines that are squeezed by mountains on either side. It is these southern ends that will prove the most interesting to photographers, though the views from the parking areas are just so-so. To get great photos from either Long Pond or Echo Lake, you will need to get out on the lake in a boat or go for a hike.

Loons are common on both lakes and can be photographed carefully from a kayak or canoe. Loons are a protected species in Maine. It is illegal to harass these icons of the north woods, and chasing loons around to get a picture of them is considered harassment. Paddle nearby and wait with a long lens (preferably 400mm or longer). Often the birds will approach within shooting distance if you are patient and show them respect. We will sometimes use a tripod in the canoe if it is calm day, and having a lens with image stabilization is a big plus.

The best views of Long Pond can be found by hiking up the steep Beech West Ridge Trail or the even steeper Perpendicular Trail on Mansell Mountain. You won't need to hike far (less than half a mile in each case), but you will

experience several hundred feet of elevation gain. Great shoreline shots can be found by hiking the easier Long Pond Trail, which skirts the western shore of the pond for about a mile.

By far, the best views of Echo Lake are from Beech Cliffs, which rise 600 feet above the southwestern shoreline of the lake. The cliffs are dotted with small pine, spruce, and Bar Harbor juniper, and the granite ledges are speckled with colorful lichens. The views of the lake are spectacular and you also get a look across the water to Acadia Mountain. There are two ways to get to the top of the cliffs: The first is the steep Beech Cliff Trail, which climbs the cliffs from below using stone staircases and iron ladders—a challenge even when you are not bogged down with photography gear. The easier alternative is to sneak in the back way, which is less steep: Take Beech Cliff Loop Trail, which starts at the end of Beech Hill Road.

**Directions:** Parking for the boat put-in, as well as the trails mentioned for Long Pond, is at the south end of Long Pond, which is at the end of Long Pond Road in Southwest Harbor. The boat put-in for Echo Lake is at Ike's Landing, just off ME 102 between Somesville and Southwest Harbor. The start of the Beech Cliff Trail is at the Echo Lake Beech Parking Area, just south of Ike's Landing off ME 102.

**Pro Tip:** It is always disappointing to return from a photo trip only to find that you missed a shot because of poor exposure or white balance, and this is especially true when you go through the extra effort of hiking or paddling for a few miles. You can compensate for some mistakes by shooting in RAW format with your digital camera instead of using jpegs. RAW files are much more forgiving than jpegs when you over- or underexpose an image or blow the white-balance setting. Changing white balance after the fact with a RAW file has no degrading

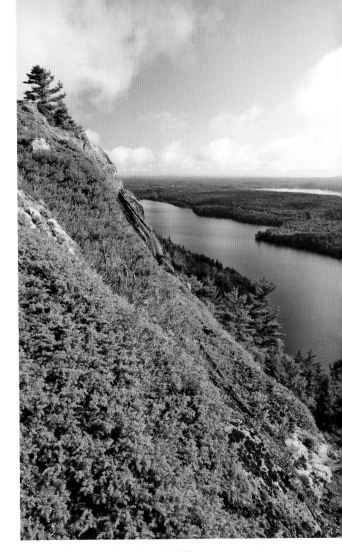

*Echo Lake as seen from Beech Cliff*

effect on most images, and recovering a stop or so of blown highlights works very well. However, bringing up underexposed shadow detail is bound to introduce noise to an image, even with RAW files, though they still work better than jpegs. If you shoot jpegs simply because you hate spending time on the computer converting RAW files, try it anyway. Most RAW processing programs have excellent automation features that really reduce the amount of time you need to spend on the computer.

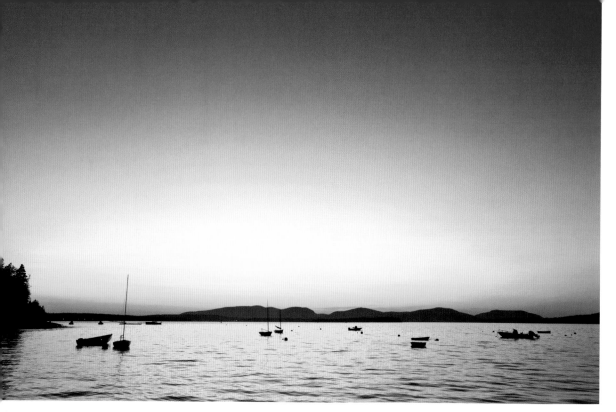

*A Cranberry Isles sunset*

# XI. Cranberry Isles

**General Description:** The Cranberry Isles consist of five small islands near the southern coast of Mount Desert Island at Somes Sound. To get to any of these islands you need a boat of some kind. Experienced kayakers can make the trip to any one of them, though it can get dangerous in the currents on the Atlantic side of Great and Little Cranberry and Baker Island, so making a trip to these places is recommended only for very experienced paddlers. Fortunately, there are ferries that run on a regular schedule from Southwest and Northwest harbors to Great and Little Cranberry, making them an easy destination for photographers. Baker Island is the only one of the Cranberries

**Where:** Off the coast of Mount Desert Island, just south of Somes Sound.
**Noted for:** Island scenery, views of Mount Desert Island.
**Exertion:** Easy walking.
**Peak Times:** Spring: early June. Summer: July and August. Fall: late September and early October. Winter: January through March.
**Facilities:** Isleford (Little Cranberry), Great Cranberry.
**Parking:** Established lots at town docks.
**Sleeps and Eats:** In Southwest Harbor, Isleford.
**Sites Included:** Isleford, Great Cranberry Island, Baker Island Light.

that is part of the National Park, and there is only one public boat trip to the island per day in the summer. Sutton and Bear islands are completely private property and are usually only visited by residents and vacationers staying in summer homes there.

**Ferry Information:** Cranberry Cove Ferry (207-460-1981) runs a ferry several times per day from the Upper Town Dock in Southwest Harbor to Great and Little Cranberry islands. The Beal and Bunker Mail Boat (207-244-3575) makes several runs to the islands per day from Northeast Harbor. With either boat, you can spend time on both islands for the one ticket. For photographers, the Cranberry Cove Ferry has the added benefit of having late return trips (8 P.M. or 10 P.M.) during some summer days, making it possible to shoot scenes with good late-day light without spending the night. Neither ferry requires reservations, and tickets ($24 roundtrip as of 2009) are purchased on the boat. Bar Harbor Tours (800-741-6142, www.barharbortours.net) offers four-hour roundtrip excursions to Baker Island for $47.95. A good on-line resource for Cranberry Isles visitor information, including ferry schedules, is www.cranberryisles.com.

*A kayak on the shore of Sutton Island in the Cranberry Isles*

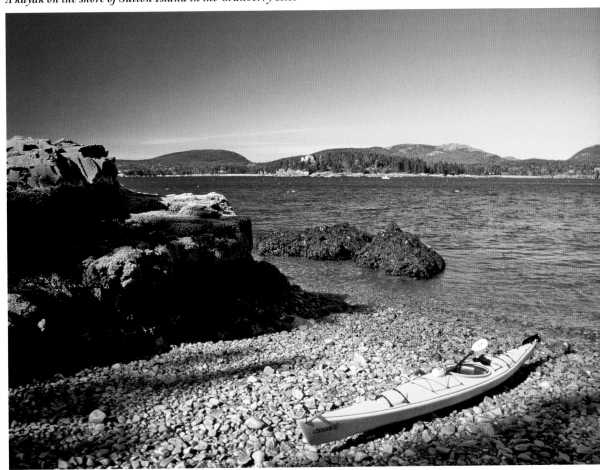

*Sunset from the town dock on Great Cranberry Island*

# Isleford (Little Cranberry Island) (42)

The Cranberry Islands were once home to a thriving community with fishing at the core of its culture, and Little Cranberry Island, also known as Isleford, was the center of activity in this community. The island is still the most vibrant of the Cranberries, its small fishing fleet sharing space with artisan shops, a restaurant, and even a B&B. Photographically, it offers good variety, with typical Maine coast shoreline, views of Mount Desert Island, and harbor scenes. Great shots can be had right from the ferry landing, but it is worth spending a few hours exploring the island on foot—it is small enough that you can see most of it in an afternoon. You'll also want to check out the Isleford Historical Museum, which is run by the National Park and contains a cool collection of objects that describe life on the islands in the 19th century.

# Great Cranberry Island (43)

Great Cranberry is the biggest of the islands, yet it maintains a relaxed and quiet atmosphere. Like Isleford, you will find great views of Mount Desert Island right from the town dock, but the rest of the island is worth explor-

ing as well. In particular, you should check out the Preble-Marr Historical Museum (about a quarter-mile walk from the dock), and the mile-long trail behind the museum. The trail (on land conserved by the Maine Coast Heritage Trust) meanders through a moss-covered forest of tall spruce trees on its way to Whistler Cove, a beautiful half-moon sandy beach bordered by cobblestones and rocky ledge. If you have time to walk the rest of the island, wander down the side streets that lead to the Pool, where you will find more great scenery with views to Isleford and the mountains of eastern Mount Desert Island.

# Baker Island (44)

The most remote of the Cranberry Islands, Baker Island was purchased by the U.S. government in 1827 to house the lighthouse that still stands there. A small number of people continued to live on the island into the early 20th century, but there are no permanent residents there now. However, some of the remnants of the island's past make for interesting photo subjects. In addition to the lighthouse, there are cellar holes, a small, windswept old cemetery, and an old school house. As with all the Cranberries, there are excellent views of Mount Desert Island from Baker. If you take the tour to Baker from Bar Harbor, have your camera accessible on the boat as well as the island. You will pass park icons such as Sand Beach and Otter Cliffs, and you may have the opportunity to photograph the harbor seals that haul themselves onto the rock ledges near Baker Island.

**Pro Tip:** If you want a different perspective of Acadia's coast, book a sea kayaking tour from one of the outfitters in Bar Harbor or Southwest Harbor. Shooting from a kayak gives a unique, water-level feel to your images, and many of the tours stop at locations that are not accessible from normal land routes. The most scenic tours visit the Porcupine Islands, Somes Sound, and Mount Desert Narrows. Most non-kayakers will feel uncomfortable carrying a camera while paddling. If that's you, stow your camera gear in a dry bag (the outfitter may have one you can use), and seal it inside the waterproof hatch on the boat. You'll want this double protection as hatches are known to leak and dry bags don't always stay that way, but we've never had a problem when using both. We like to have our cameras available while paddling, either in a dry bag stashed in the cockpit or hanging around our necks, with the camera straps cinched way up. We only recommend this when seas are calm and for experienced paddlers, who rarely capsize and who insure their gear against doing such foolish things. You will also want to keep some lens cloths handy to wipe salt spray off your lens.

*Kayaking offers a unique perspective for photography in Acadia.*

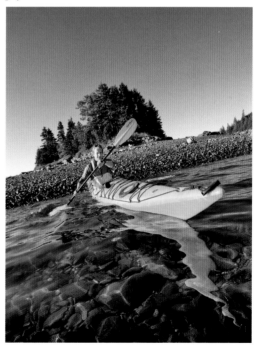

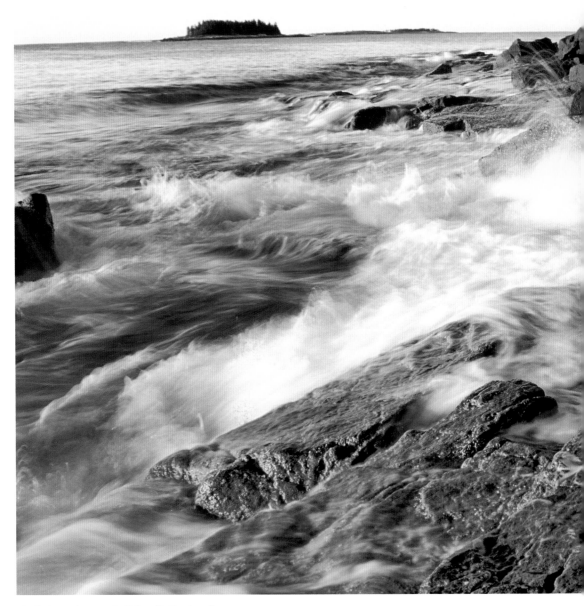

*Early morning on the Schoodic Peninsula*

# Beyond Mount Desert Island

## XII. Down East

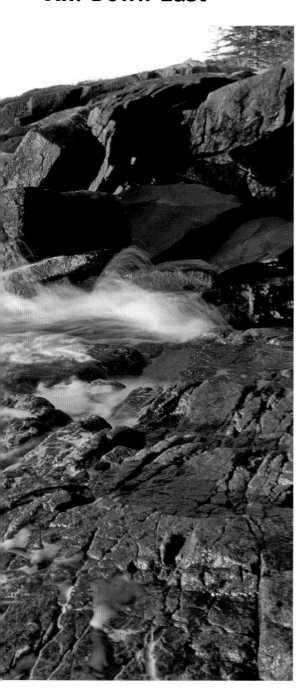

**Where:** The Maine coast east of Mount Desert Island.
**Noted for:** Dramatic coastline, lighthouses, working harbors, Atlantic puffins.
**Exertion:** Easy walking to moderate hiking.
**Peak Times:** Spring: early June. Summer: July and August. Fall: late September and early October. Winter: January through March.
**Facilities:** Schoodic Peninsula, Jonesport, Lubec.
**Parking:** Established lots.
**Sleeps and Eats:** In Winter Harbor, Jonesport, Lubec.
**Sites Included:** Schoodic Peninsula, Corea, Jonesport, Cutler, Great Wass Island, Machias Seal Island, West Quoddy Head, Lubec.

**General Description:** While the term "down east" is often used to refer to the coast of Maine east and north of Portland, true Down East is the stretch of coast (90 miles if you follow US 1, hundreds of miles if you actually measure the coastline) that runs from Hancock to West Quoddy Head, the easternmost point in the U.S. This is the last piece of Maine coast with a real authentic feel—a small population living in tightly knit, spread-out villages where harvesting timber and blueberries is as important as the commercial fisheries that still define the small working harbors. People here work hard to make ends meet amongst some of the most beautiful scenery in Maine. For the photographer, this area is rife with subject matter, from the remote headlands and cobble beaches of the coast to the details of harbor life. Throw in

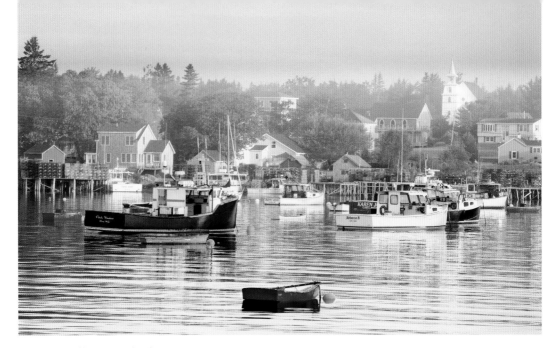

*Fog burns off in Corea harbor*

a few lighthouses and the opportunity to visit a colony of nesting Atlantic puffins and razorbill auks, and you could easily spend a month making a diverse collection of images here. The Schoodic Peninsula is the only place in this section that is part of Acadia National Park, but if you are making an extended visit to the park, you will want to spend some time visiting all of these locations, which lie one to two hours from Bar Harbor.

**Directions:** To get Down East, you will need to drive US 1 east from Ellsworth. Specific directions for each location are listed below.

## Schoodic Peninsula (45)

The Schoodic Peninsula is the only part of Acadia that is on the mainland, and it is a great place to explore dramatic Acadia coastal scenery without the crowds that descend on Mount Desert Island. The 6-mile, one-way park road on the peninsula is where you will want to spend most of your time, but plan on stopping a few times before then on the drive between Hancock and Winter Harbor, as there are plenty of roadside pull-offs with great scenery. On the one-way road (marked as Moore Road in Winter Harbor), the first photo op is a pull-out with views of the Winter Harbor Lighthouse with Cadillac Mountain in the distance, about half a mile from Winter Harbor. The stretch of coastline between here and Schoodic Point has abundant vistas of cobble beaches and views west to Mount Desert Island. Five miles from Winter Harbor, you reach Schoodic Point itself, an area of small jack pines set above extensive rock ledges and views of Frenchman Bay and the mountains of Acadia. The point is fully exposed to Atlantic Ocean swells, so this is a great place to photograph crashing surf—just be careful not to get swept away.

Beyond Schoodic Point the coast faces east, providing photographers with ideal sunrise photography opportunities. Pink and brown rock ledges provide good foreground subjects

for landscape shots of crashing waves, offshore islands, and open ocean. Three hiking trails lead to the top of nearby 440-foot-tall Schoodic Head, which has panoramic views of the area. At .5 miles, the East Trail is the shortest of these hiking options. Just a few miles beyond the end of the park road, on ME 186, is Prospect Harbor, whose east-facing harbor filled with fishing boats makes another good sunrise photo spot.

**Directions:** To get to the park road on the Schoodic Peninsula, drive east on US 1 from Ellsworth. In West Gouldsboro, turn right onto ME 186 and drive 6.5 miles to Winter Harbor, where the road dead-ends. Turn left and follow the road for .5 miles to Moore Road and signs that point to Acadia National Park. Turn right here to begin your drive around Schoodic.

# Corea (46)

If you visit Schoodic, you might as well make the short drive to Corea as well. This little harbor seems like a place lost in time. Pretty homes and lobster shacks share the shoreline with docks covered in stacks of lobster traps and piles of buoys. It is truly a working harbor, as the lobster boats outnumber sailboats by about 20 to 1. The easiest place to shoot, from an access point of view, is from the fishing co-op at the end of the road that leads left where ME 195 ends. Since there is no public access here, make sure you find legal parking and ask permission to shoot from the dock area.

**Directions:** From the intersection of ME 186 and ME 195 in Prospect Harbor, head east on ME 195. You'll reach Corea in about 3.2 miles.

# Jonesport (47)

Combined with nearby Beals and Great Wass Islands, Jonesport offers a little bit of every-

thing for the traveling photographer, including fishing fleets, old churches, and stretches of unspoiled coastline. Jonesport proper is a large village situated on an east-facing harbor, replete with several piers that are home to a fleet of lobster and commercial fishing vessels. What you won't find are the usual Maine coast tourist offerings of gift shops and clam shacks (so get your lobster T-shirt and fried scallop fix

*Blue flag iris at the Great Wass Island Preserve*

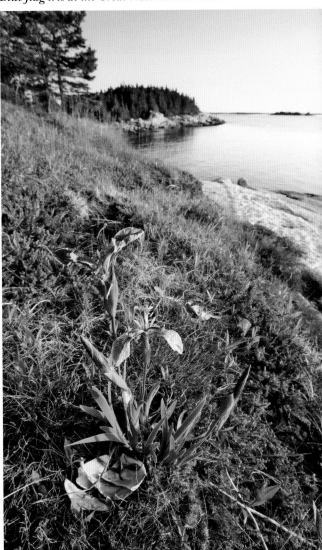

in Bar Harbor). The best photos come from walking the piers and shooting sunrise and sunset scenes of the harbor from the bridge that leads to Beals Island, next to the U.S. Coast Guard Station. Jonesport is also one of two embarkation points for the trip out to Machias Seal Island—more about that below.

**Directions:** Jonesport is on ME 187 about 11 miles from US 1 in Columbia Falls.

## Beals Island and Great Wass Island (48)

The main attraction to Beals Island is the town landing, where there are great harbor views and the usual lobstering paraphernalia to go with them. It is one of those places where you can shoot in both morning and afternoon light, making big scenics, shooting details, or just experimenting with the reflections of boats in the water. Beyond Beals is Great Wass Island, which has two main attractions: the Downeast Institute for Applied Marine Research and Education (www.downeastinstitute.org) and The Nature Conservancy's Great Wass Island Preserve. The Downeast Institute is associated with the University of Maine in Machias, and features a hatchery that grows and sells various shellfish such as clams and lobsters. On most weekdays you can get a tour of the indoor facility, where you will be treated to tanks full of larvae and our favorite, the shelves full of glass containers of algae—it looks like a lab right out of a mad-scientist movie. Outside, there are lobster pounds and a dock with great views to the west.

Across the street from the Downeast Institute is the Great Wass Island Preserve, 1,540 acres of spruce woods and bogs in addition to several miles of rocky coastline. The best photography in the preserve requires walking the 2-mile Little Cape Point Trail, which, when combined with the Mud Hole Trail and 1.5

miles of shoreline walking, makes a nice 5-mile loop hike. The Little Cape Point Trail passes through woods and over a bog on wooden bridges (look for sundew and pitcher plants), before reaching the beautiful, undeveloped shoreline on the east side of Great Wass Island. Walking the coast here is a joy, as you go up and over granite ledges that border numerous cobblestone beaches. The best photos here are made first thing in the morning. Camping is not allowed in the preserve, which means you will need to get up early and spend 45 minutes to an hour hiking in predawn light if you plan to shoot the sunrise. While there's no guarantee, bald eagle and harbor seal sightings are common in the preserve, so if you don't mind lugging a big lens through the woods, you may be rewarded with some wildlife photo opportunities as well.

**Directions:** To get to Beals and Great Wass islands, follow Bridge Street from ME 187 in Jonesport. Once over the bridge, follow the road to the left. The next left, Perio Point Road, will take you to the Beals Island town landing. Continuing straight will bring you to Great Wass Island on Great Wass Island Road. After you've crossed the causeway to Great Wass, follow signs to the Downeast Institute and the Great Wass Island Preserve (just stay right whenever the road forks). When you come to Wildflower Lane (about 3 miles from Beals Island), the institute is to the right and the preserve is just ahead on the left.

## Machias Seal Island (49)

This 20-acre rock sits in the Gulf of Maine about 10 miles off the coast of Cutler, and it has been a Mecca for birders and photographers for decades. The island is actually managed by the Canadian Wildlife Service, but some local Mainers claim it is U.S. territory (a flotilla of armed lobster boats actually surrounded the is-

land in the early '70s, but nothing came of the provocation). For photographers, it is a truly wonderful place to visit as it is home to hundreds of pairs of nesting Atlantic puffins, razorbill auks, and common terns. There are several blinds on the island that provide up-close viewing of the birds, which are sometimes so near you can photograph them with fairly normal-length lenses. Bringing a variety of focal lengths is recommended, however, as the birds are not always so cooperative. Know how to use your equipment before you get there, as you are only allowed two or three 20-minute sessions in a blind and you'll be sharing it with two or three others.

The birds are primarily on the island to nest, so they are only present from late spring through summer. June and July are the best times to go, as the birds are building nests early during that time frame and bringing mouthfuls of fish to the chicks (hidden away in burrows) after they hatch. There are some things to know before you go. Actually getting on the island and in the blinds is not a sure thing, as there is no safe harbor there; the seas must be calm enough for visitors to jump off a skiff onto the metal walkway bolted into the rocky shoreline. If the seas are too rough to do this safely, your captain will just give you a tour of the island from sea—still fun and full of puffin sightings, but not as ideal for photography. We recommend booking two days for this trip to have a better chance to experience favorable weather. Also, book your trip well in advance—January is not too early. The wildlife service limits the number of daily visitors to the island in order to protect the birds, and the trips fill up quickly. Also, when you book, make sure

*Puffins fly from a blind on Machias Seal Island.*

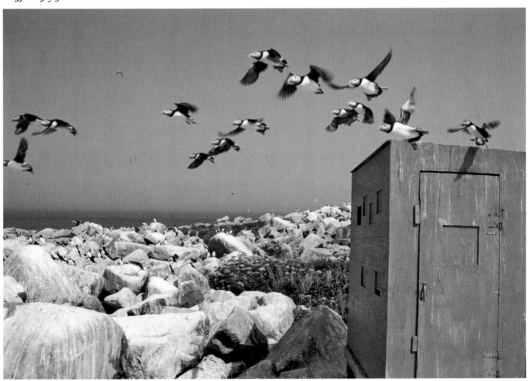

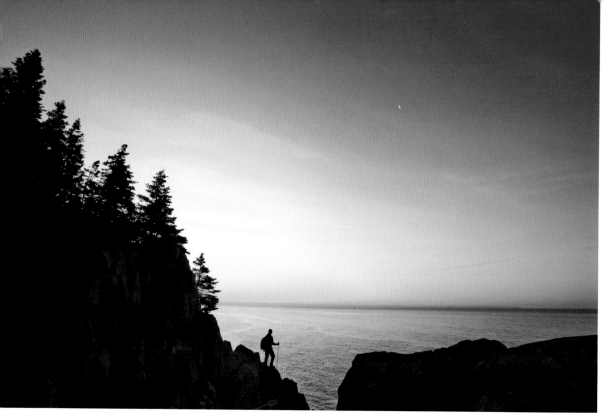

*A lone hiker at sunrise on the Bold Coast in Cutler*

your name is on the list to get on the island. Since tour boats are often crowded, not all passengers will be permitted to leave the boat and access the island and the blinds. If you're only interested in seeing Atlantic puffins and adding them to your life list, you'll be fine, but for access to the island and maybe the blinds, if they're not too crowded, book early and try to cover all your bases.

**Boat Access:** There are two companies that lead tours to Machias Seal Island: Norton of Jonesport (www.machiassealisland.com), which leaves from Jonesport, and Bold Coast Charter Company (www.boldcoast.com), which runs tours out of Cutler. We have travelled with both companies and found that each offers an excellent experience. The tour costs $100 with either company as of 2009.

## Cutler (50)

Cutler is a tiny little harbor that is as scenic as any other Down East, but the real fun for photographers in Cutler is the dramatic shoreline known as the Bold Coast. This rocky stretch between Cutler and West Quoddy Head is wild, beautiful, and mostly undeveloped. The main photo hot spot is the Bold Coast Preserve, accessed by a hiking trail that begins on ME 191, about 4 miles northeast of Cutler. Photography here takes some moderate hiking, but the opportunities are superb as the Bold Coast features towering cliffs that rise 50–75 feet above the crashing surf of the Atlantic. Twenty miles across the water are the cliffs of New Brunswick's Grand Manaan Island. In early summer, you'll find wild roses, blue flag irises, and other wildflowers on and near the cliffs.

The coast here faces southeast, so early morning is a great time to shoot in the good light.

The quickest route to the cliffs is by hiking the Cutler Coastal Trail 1.5 miles to where it hits the coast and turns right, following the top of the cliffs for about 2 miles to Black Point Cove, where there is a lovely cobblestone beach that is almost always devoid of people. From Black Point Cove you can return via the inland Black Point Loop Trail for a total hike of almost 6 miles. You can also follow the Coastal Trail for another 2 miles to Fairy Head, making a total hike of 10 miles. Backcountry camping is allowed at established sites at Black Point Cove and Fairy Head, but there is no re-liable fresh water at either site, so you'll need to carry that in if you decide to spend the night. While you will never be more than 150 feet above sea level, either loop hike is going to rise and fall, following the cliffs, easily bringing the total elevation gain of a hike here to several hundred feet.

**Directions:** Cutler is on ME 191, about 13 miles south of US 1 in East Machias.

# Lubec (51)

Continuing east from Cutler brings you to Lubec and a bridge to Canada. Lubec was once the center of the herring industry in Maine,

*Lubec dock after sunset*

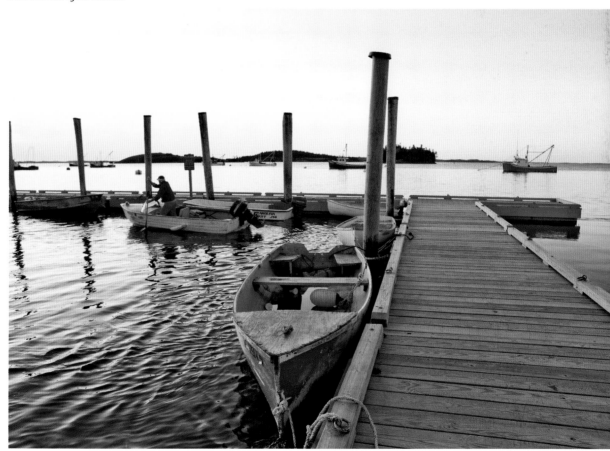

having been home to a large fishing fleet and several canneries. As fish stocks declined in the mid-20th century, so did the fortunes of Lubec, with the last cannery shutting down in 1991. These days, the town seems to be starting a re-birth as a few trendy inns have opened on Main Street, and outdoor enthusiasts are starting to discover the area's superb sea kayaking and

*West Quoddy Head Lighthouse*

wildlife watching. Photographically, most of the interesting images will be found at the town pier, which offers views of the remaining fish-ing fleet, offshore islands, and a lighthouse across the water in New Brunswick. The sun-set views from the dock are excellent. You can also check out the last standing cannery, which is just up the hill from the dock and is being re-stored as a museum, chronicling the ups and downs of Lubec's commercial fishing past.

**Directions:** Lubec is at the end of ME 189, 11 miles east of US 1 in Whiting.

# West Quoddy Head (52)

If you have made it to Lubec, you might as well check out West Quoddy Head, the eastern-most point in the U.S. Like the Bold Coast trails in Cutler, West Quoddy Head State Park has a system of hiking trails which follow the ups and downs of the cliffs facing the Atlantic, though these trails don't require quite as much effort before you arrive at the dramatic views. The park also has a trail that traverses a beauti-ful bog surrounded by conifers that harbors dozens of interesting plants, including pitcher plants and sundews. If you don't feel like hiking, you're still in luck, as yards from the parking area stands the stunning red-and-white-striped West Quoddy Head Lighthouse. Surrounded by a well-manicured lawn, the light is perched on top of a cliff that drops dra-matically to the rocks and water below. The lighthouse is beautifully front-lit by the setting sun, and silhouetted by sunrise light in the morning. If you want a wilder view of the light, hike the coastal trail for about .5 miles to where you get a view of the lighthouse rising out of a forest of pointy spruce trees.

**Directions:** Just before reaching Lubec on ME 189, follow South Lubec Road south for a lit-tle more than 4 miles, following signs for the state park.

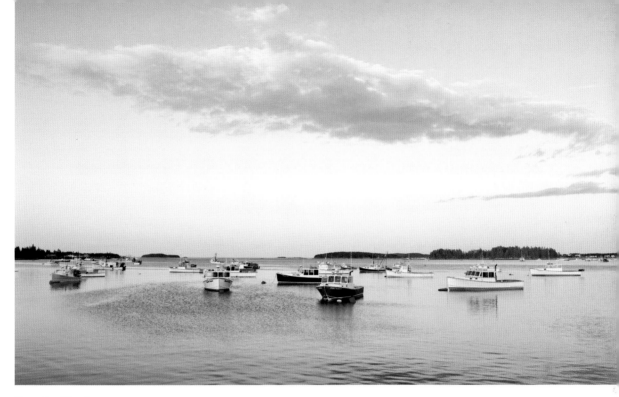

*Jonesport harbor*

**Pro Tips:** The cliffs and coves, like those found on Cutler's Bold Coast, often provide the challenge of balancing exposures to capture both bright highlights and deep-shadow details. While a graduated, split-neutral density filter can help when there are obvious and straight demarcation lines between highlights and shadows (such as the horizon), there are many scenes where this just isn't the case. For these situations, there is no way to get one exposure that captures the scene the way your eyes see it. Enter high-dynamic range (HDR) processing. In the last few years, there has been a popular movement in the digital photography world to blend together several exposures using a process that gives your image a high dynamic range. The procedure usually involves shooting several exposures of a scene, one to two stops apart, while your camera is held in one place by a tripod. Those images are then blended together using software that takes the well-exposed highlights from some images and combines them with the shadow details of others. Sometimes this looks great, sometimes it looks weird, like something out of a Harry Potter movie. It is fun to do, however, and we have made several HDR images that we are very pleased with. Some tips: 1) Three exposures, two stops apart, are usually sufficient, but check your histogram to make sure you are getting highlight details and shadow details in your image series. 2) Change your shutter speed between exposures, not your aperture. 3) Focus before your first image, then turn off autofocus. 4) Shoot in RAW format. Photoshop has a Merge-to-HDR feature, but we find it much harder to use than programs such as Photomatix (www.hdrsoft.com) and the Enfuse plug-in for Lightroom (www.photographers-tool box.com/products/lrenfuse.php).

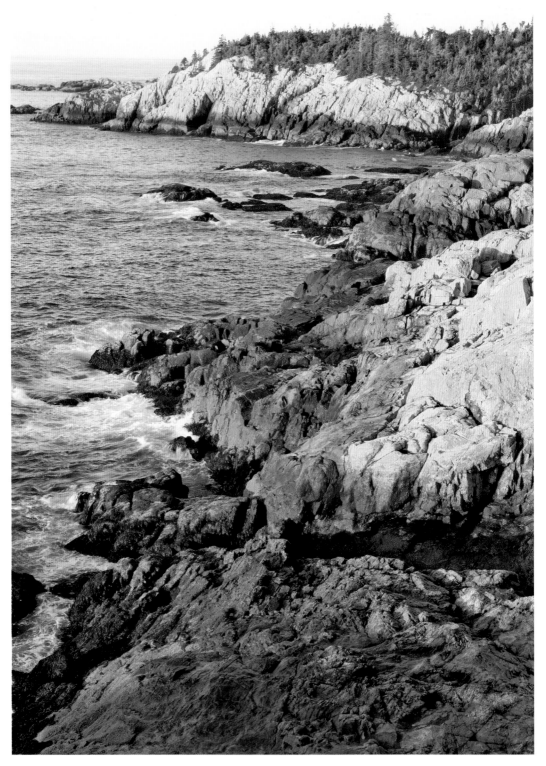

*Isle au Haut*

# XIII. Isle au Haut and Blue Hill Peninsula

**General Description:** Isle au Haut is a part of the park that requires a 6-mile boat ride from Stonington, which is about an hour's drive from Mount Desert Island. It is like the rest of Acadia in that it has great hiking and a dramatic coastline, but it only sees about 10,000 visitors a year compared to the 2 million who make the trip to Mount Desert. Six miles long and 2.5 miles wide, Isle au Haut tops out at 566 feet, making it the hilliest of Maine's offshore islands, hence its name, which means "high island" in French. On the way to Isle au Haut, you will drive through the Blue Hill Peninsula and Deer Isle, and outside the park you will find lots of other photo opportunities in some of the prettiest little harbor towns in Maine. Almost every side street in this area leads to a photo op, but we've narrowed it down to the few highlights listed here.

**Directions:** To get to the Blue Hill Peninsula and Isle au Haut, you will need to drive ME 172 west from Ellsworth. Specific directions for each location are listed below.

## Castine (53)

Castine is home to the Maine Maritime Academy as well as a significant fleet of sailboats, which makes it a really interesting harbor to photograph. The town was originally settled by the French in the early 18th century, and was the scene of many skirmishes between the French and British. Many of the homes near downtown display the fleur-de-lis or Union Jack in the front yard to indicate the origin of the original inhabitants. Besides the harbor, you will find the local architecture to be worthy of photographs, as it is truly a beautiful village. At the end of Battle Street on the west

> **Where:** Western Penobscot Bay.
> **Noted for:** Dramatic coastline, scenic harbors.
> **Exertion:** Easy walking to moderate hiking.
> **Peak Times:** Spring: early June. Summer: July and August. Fall: late September and early October. Winter: January through March.
> **Facilities:** Duck Harbor, Blue Hill, Castine, Stonington.
> **Parking:** Established lots.
> **Sleeps and Eats:** In Blue Hill, Castine, Stonington, Isle au Haut.
> **Sites Included:** Isle au Haut, Blue Hill Reversing Falls, Castine, Deer Isle, Stonington.

side of town, you can photograph the Dice Head Lighthouse, which sits on a cliff overlooking the mouth of the Penobscot River. Late-day light works best at the lighthouse, while the harbor can be shot at both sunrise and sunset.

**Directions:** You'll want a map to get to Castine, as there is no direct route there. The best bet, if you drive to the area on ME 172 from Ellsworth, is to turn right on ME 177 in Blue Hill, then turn right on ME 175 in South Penobscot. Turn left onto ME 199 in Penobscot, left again on ME 166 in another few miles, and follow ME 166 into Castine.

## Blue Hill Reversing Falls (54)

Just outside the pretty little town of Blue Hill is a tidal pond that fills up and empties out in grand fashion, creating an exciting rush of cascading whitewater with standing waves. The key to seeing the falls is to go when the tide is changing, especially as it moves from high to low tide (at actual high tide and low tide, the water is boring and relatively flat). If you can

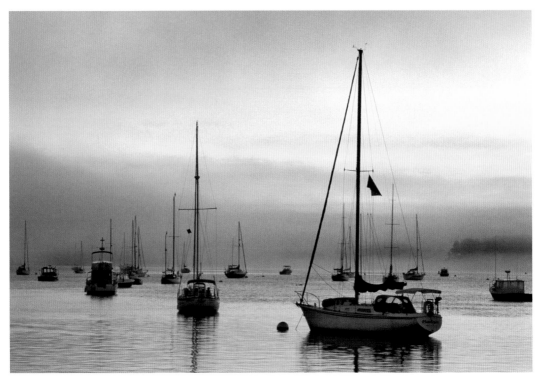

*Morning fog in Castine*

be there for sunrise and an outgoing tide, you will maximize your photo opportunities. The falls face the rising sun and there is a nearby cove with a few boats and an offshore island topped by spiky spruce trees. Classic Maine.

**Directions:** From Blue Hill, follow ME 175 south for 3 miles. There is parking on the side of the road. The area is surrounded by private homes, so please be sure not to park in someone's driveway and to respect the property of others.

## Deer Isle (55)

Between the Blue Hill Peninsula and Isle au Haut are Deer Isle and Little Deer Isle, two islands accessible by car by driving ME 15 over an amazingly tall and steep bridge for such a remote area. There are numerous places to find great pictures on these islands, but we have two favorite spots. The first is the causeway on ME 15 that connects Little Deer Isle to Deer Isle (this causeway is just past the big bridge). There are plenty of places to park on the causeway and even a beach on the west side of the road. There are views both to the east and the west, and with good late-day or early morning light, there are numerous compositions to play with, especially if you like to silhouette islands, skiffs, etc., against a colorful sky.

The second location is Pumpkin Island Light. This lighthouse is about a quarter mile offshore at the northwestern tip of Little Deer Isle. To get there, just turn right on Eggemoggin Road after crossing the big bridge. There is parking where the road dead-ends into a snug little cove that harbors a few sailboats, which make nice foreground material for the

landscape shots that include the lighthouse in the distance. In summer the sun sets almost directly behind the lighthouse, so with a good sunset sky you can get some really interesting images here.

**Directions:** To get to Deer Isle, follow ME 15 south from Blue Hill for 13 miles. (At 4.7 miles, be sure to turn left to stay on 15 at an intersection with ME 176. At 10.6 miles, you will need to turn right to stay on ME 15 at an intersection with ME 175.)

## Stonington (56)

At the southern tip of Deer Isle, and the embarkation point for the boat ride out to Isle au Haut, Stonington is wonderful place to photograph as well. There are several places to shoot harbor scenes, with morning the best time to shoot in either golden light or the thick fog that is common here. The pier where the Isle au Haut mail boat takes off gives a good overview of the harbor. Down the street to the west is the commercial fishing pier, where you can find lobstermen at work and a great collection of dinghies on a floating dock. Driving east from the mail-boat pier gives you additional views of the harbor. You will also find walking down Main Street with your camera a worthwhile endeavor. A working person's town, Stonington is also home to a couple of good restaurants and art galleries. If you want more of a nature experience, drive west a few miles from town on Burnt Cove Road to The Nature Conservancy's Crockett Woods Preserve, where you can experience and explore a beautiful coastal Maine spruce forest.

**Directions:** Stonington is at the end of ME 15, about 24 miles south of Blue Hill.

*Lobster buoys in Stonington*

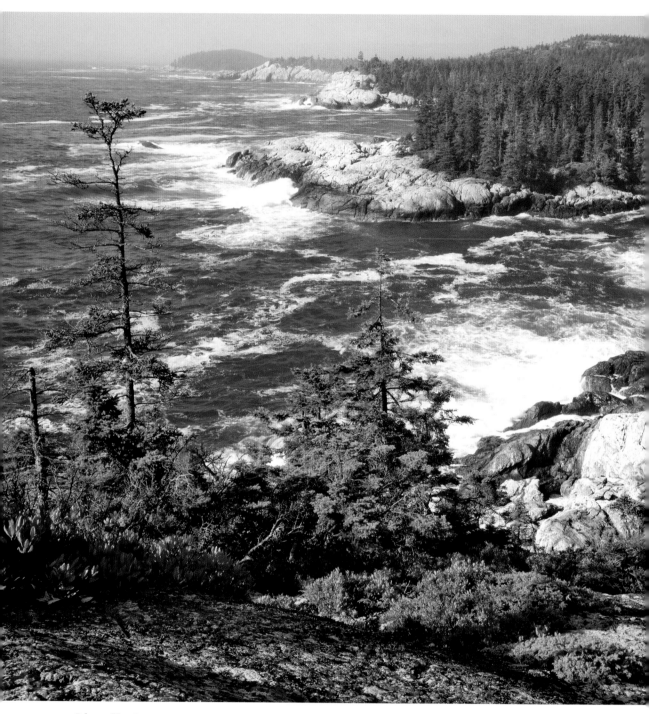

*Isle au Haut*

# Isle au Haut (57)

The coast of Maine is dotted with hundreds of islands, with more than 30 in western Penobscot Bay in what is known as the Acadian Archipelago. Located at the southern reaches of the bay, Isle au Haut is one of the jewels of the archipelago, its southern headlands and coves jutting out into the Gulf of Maine and receiving the full force of the swells that plow in from the open Atlantic. The island was once home to a community of more than 300 people, who used the island as a jumping-off point for the rich fishing grounds nearby. There is still a permanent community of about 30 people here, and a quiet yet vibrant summer population of a few hundred. Most of the southern half of the island, 2,700-plus acres, is part of Acadia National Park, and it is an excellent example of what Maine's islands are like in an undeveloped, wild state.

It is possible to make a day trip to the island by taking the mail boat from Stonington and hiking the coastal trails for a few hours before heading back. However, photographers will want to spend a few nights here to really capitalize on the photo opportunities. There are a couple of B&Bs on the island, and in Duck Harbor the park maintains a set of lean-tos that make the best base camp for easily visiting the prime photo sites. The park's trail system on the island gives access to both inland forest scenes and dramatic coastal vistas. Some of the trails are strenuous at times, but never for more than half a mile or so. From the lean-tos you will want to explore the Duck Harbor Mountain Trail and three coastal trails: Western Head Trail, Cliff Trail, and Goat Trail. The summit of Duck Harbor Mountain has a great view of the forest and coast from up high. The coastal trails follow the tops of cliffs and drop down into secluded little coves of pink granite ledge, dark basalt bedrock, and cobblestones.

The headlands and coves along Cliff and Goat trails face southeast, making them ideal for early morning photography, while the Western Head Trail offers sunset views of Penobscot Bay. Duck Harbor itself and Ebens Head on the other side of the harbor are also excellent sunset locations that require less walking from the campground.

On a foggy or overcast day, you will want to check out the 4-mile-long Duck Harbor Trail, which connects the campground to the main harbor in the town of Isle au Haut. It passes though mossy, mature spruce woods draped with old man's beard lichen and through boggy areas filled with pitcher plants and cotton grass. It also sneaks a visit to a couple of cobblestone beaches before reaching the town,

which has a beautiful harbor filled with lobster boats and the requisite skiffs and other gear.

**Getting to Isle au Haut:** The trip to Isle au Haut is part of the fun of visiting this "Acadia away from Acadia." Unless you have your own boat, you will need to drive to Stonington and take the mail boat, which is operated by the Isle au Haut Company. From the middle of June through late September there are two daily trips between Stonington and Duck Harbor, which is where the National Park campground is. There are also several trips a day to the Isle au Haut town landing during this period. If you decide to visit early or late in the season, there is no service to Duck Harbor, but there are two daily trips to the Isle au Haut town

*Dawn in Stonington*

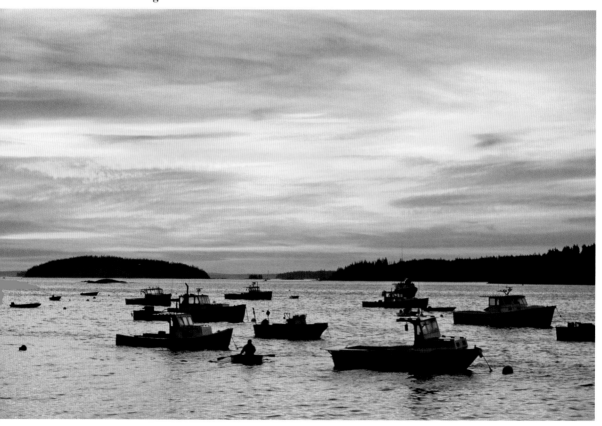

*Isle au Haut coastal detail*

landing and you can hike the 4 miles to the park from there. As of this writing, tickets are $17.50 (one-way) for adults and $9.50 for kids younger than 12. Reservations are not accepted, and tickets are sold on a first-come, first-served basis, though those with campground reservations are given priority. To confirm the schedule and rates, you should contact the Isle au Haut Company at 207-367-5193 or visit its Web site, www.isleauhaut.com. The trip takes approximately 45 minutes.

If you want to camp at Isle au Haut, you will need to make advance preparations. The Duck Harbor campground has five lean-tos but no tent sites, though tents can be pitched inside the lean-tos if they fit. The campground is open from May 15 through October 15 and reservations are required. Depending on the time of year you visit, you are allowed to stay a maximum of between three and five nights, and must pay a special use fee of $25 no matter how long you stay (there is no additional camping fee). As of this writing, reservations are accepted beginning April 1, and the sites fill up very quickly, especially for the summer months. For reservation information, visit the park service Web site at www.nps.gov/acad/planyourvisit/duckharbor.htm.

**Pro Tip:** If you opt to spend four or five nights at the Duck Harbor campground on Isle au Haut, you may run into two problems if you do a lot of shooting: running out of battery power and running out of memory card space (don't expect electricity for your battery charger or laptop). In warmer weather, SLR batteries tend to last pretty well between charges, but for an extended trip you will want at least one or two backup batteries. To save battery power, you can do three basic things. First, shoot in manual focus mode as much as possible, as the auto-focus (and image stabilization, for that matter) uses plenty of juice. Second, turn the camera off when you are not using it and turn on the auto-power off feature in case you forget. Third, minimize the use of your camera's LCD, as it is a huge power hog. You can do this by 1) not using the live view feature, 2) minimizing the amount of time you play back your images, and 3) setting your camera to display new images for only one or two seconds, as opposed to four or eight seconds.

As for running out of memory, you can either invest in a large number of memory cards or bring along portable hard drives that are specifically made to run on battery power and have slots for memory cards. This is the more expensive option, unless you are going on very long trips, but some of these portable drives are handy because they have really nice LCDs to use for reviewing the status of your photo shoot and can hold hundreds of gigabytes of data. As with all hard drives, we recommend buying these in pairs so that you can make duplicate copies of your images, safeguarding you against a hard-drive failure. The Epson P-series Photo Viewers are excellent, though pricey. We have also had success using the less expensive SanHo Hyperdrive Colorspace Media Drives. Of course, these drives need power too, so you'll probably want back-up batteries for them as well.

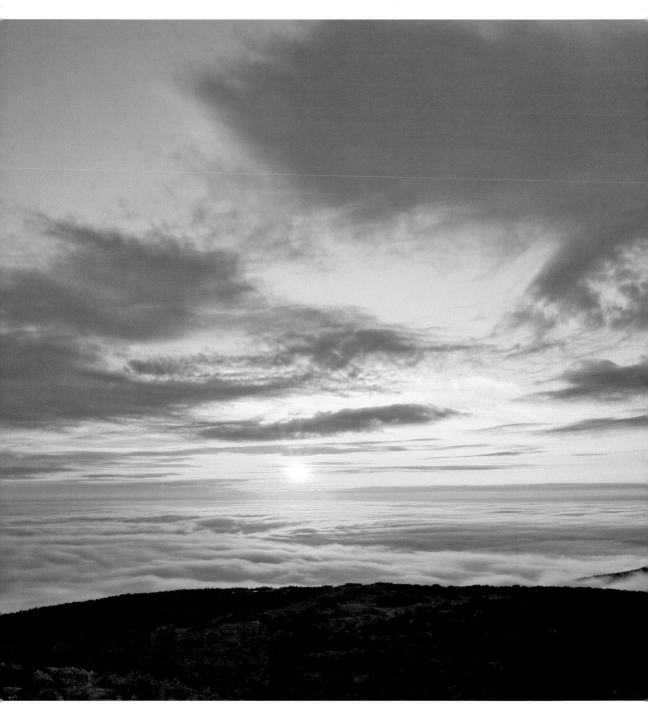

*Sunrise from Cadillac Mountain*

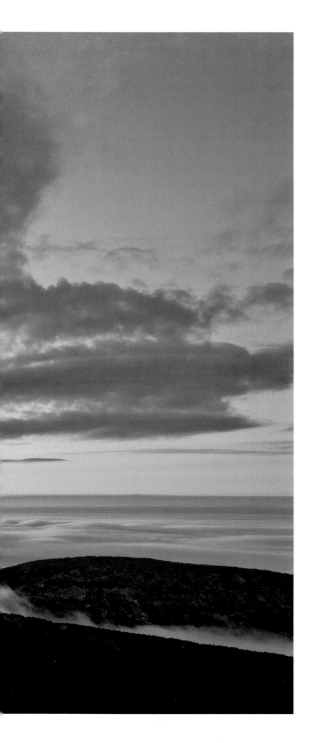

## Sunrise Locations

1. Cadillac Mountain
2. Great Head
3. Monument Cove (Ocean Drive)
4. Cutler Bold Coast Trail
5. The Beehive
6. Schoodic Peninsula
7. Dorr Point
8. Blue Hill Reversing Falls

## Sunset Locations

1. Pretty Marsh
2. Cadillac Mountain
3. Bass Harbor Head Light
4. Schoodic Peninsula
5. Isleford
6. Manset
7. Isle au Haut
8. Blagden Preserve

*After sunset in Mansett*

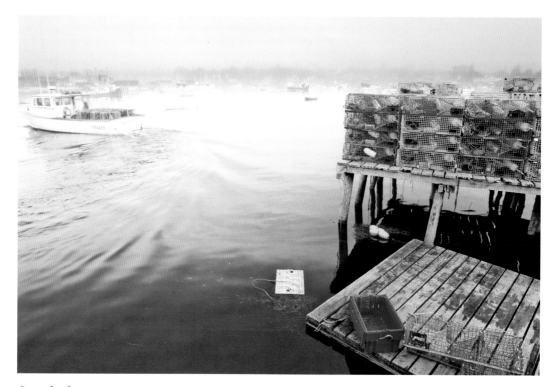

*Corea harbor*

*Skiffs on Beals Island*

# Harbors

1. Stonington
2. Isle au Haut
3. Bass Harbor and Bernard
4. Manset
5. Beals Island
6. Bar Harbor
7. Corea
8. Lubec

## Rocky Coast

1. Ocean Drive
2. Cutler Bold Coast
3. Wonderland
4. Isle au Haut
5. Great Wass Island
6. Schoodic Peninsula
7. Little Hunters Beach

## Villages

1. Somesville
2. Corea
3. Castine
4. Stonington

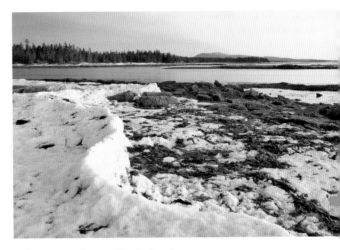

*Winter morning at Wonderland*

*Winter in Monument Cove near Ocean Drive*

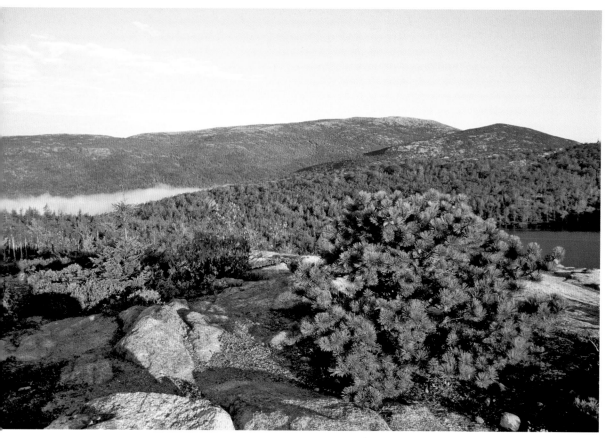

*The view of Cadillac Mountain from the Beehive*

# Woodlands

1. Sieur de Monts
2. Asticou Trail (near Jordan Pond)
3. Valley Trail (near Long Pond)
4. Great Cranberry Island
5. Pretty March Picnic Area
6. Blagden Preserve
7. Isle au Haut

# Mountain Summits

1. Cadillac Mountain
2. The Beehive
3. Acadia Mountain
4. The Bubbles (Bubble Rock)